ACCESSORIES

Rings

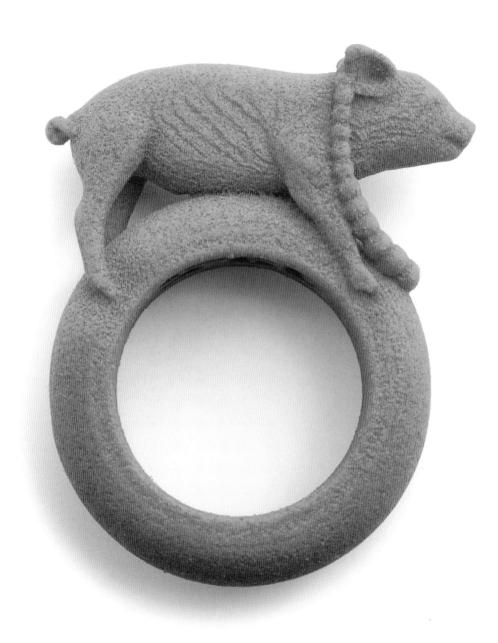

ACCESSORIES

Rings

Rachel Church

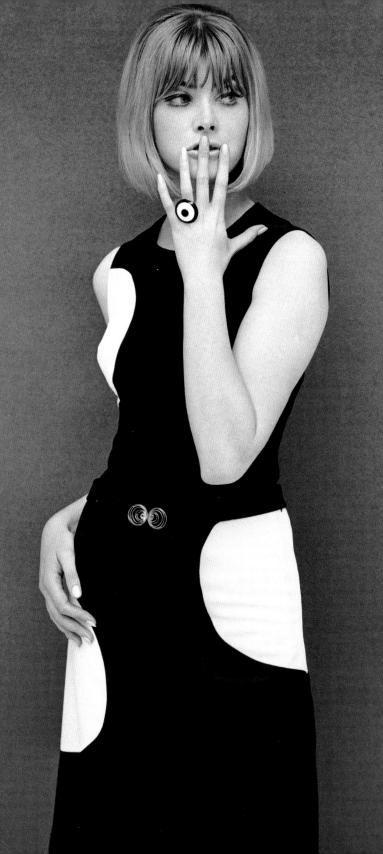

Contents

Introduction	0
CHAPTER ONE 1200–1500	10
CHAPTER TWO 1500–1700	30
CHAPTER THREE 1700–1820	60
CHAPTER FOUR 1820–1900	82
CHAPTER FIVE 1900–1950	98
CHAPTER SIX 1950–The Present	118
References	150
Glossary Further Reading	151
Notes	152
The Origins of the V&A's Collection	155
Major Collections Featuring Rings	156
Acknowledgments	156
Author's Biography	156
Index	157

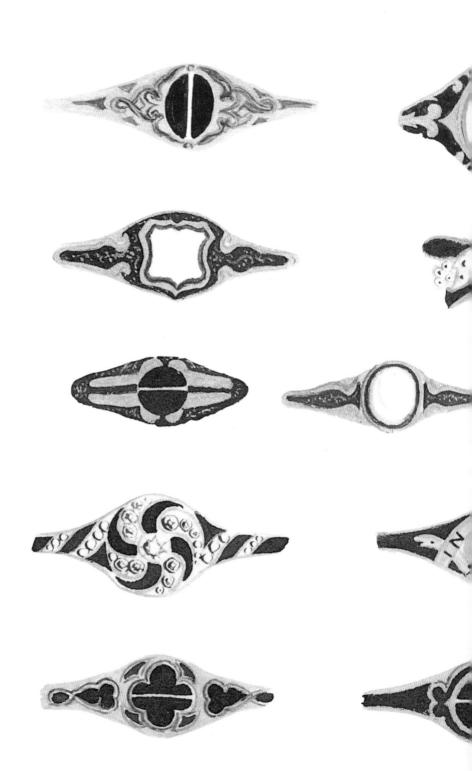

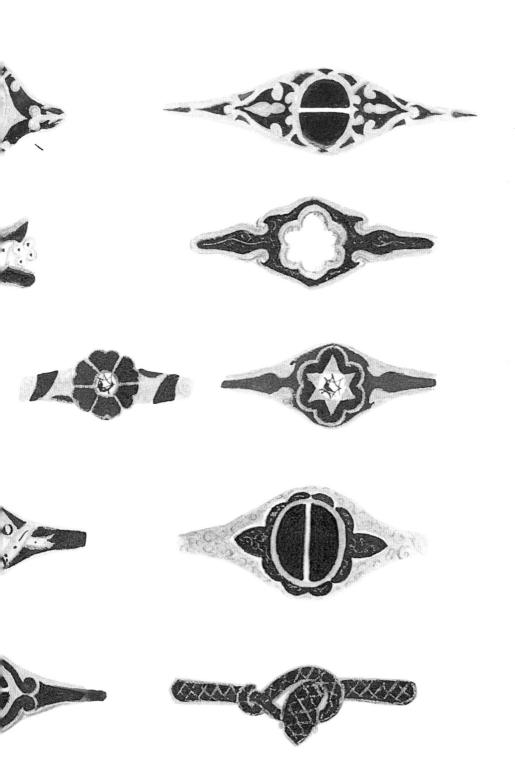

Introduction

Rings are the most common and perhaps the most evocative pieces of jewellery. Worn as a sign of love or as a fashion accessory, to mark weddings, to remember the dead, or to show religious faith, they hold a multitude of meanings. They might also display less private sentiments, by reflecting the currents of politics and public events. This book is an introduction to rings made in Europe and in the Western tradition from the Middle Ages to the present, selected from over 2,000 examples held in the exceptional collection of the Victoria and Albert Museum (V&A), London.

Throughout history rings have followed trends in the wider decorative arts: to study rings is to study a miniature history of art and design, and the influence of many key artistic developments. Designs were disseminated through books, trade in gemstones and jewellery, and itinerant goldsmiths transmitting new fashions. The finished piece of work often resulted, as it does today, from close collaboration between the ieweller and the customer. Rings were traditionally made from precious metals such as gold and silver, alongside the cheaper alternatives of bronze, iron or tin; however, gemstones, enamels, ivory, wood and, for modern jewellers, plastics, acrylics and recycled materials have all found their place.

Many rings can be divided into three main elements – the hoop, the bezel and the shoulder – each of which may receive its own decorative treatment. The hoop (also called the shank), which encircles the finger, can be plain, enamelled, engraved or inscribed. The bezel is the most salient part of many rings – it is the most visible and generally has the greatest decorative interest – and might be set with a gemstone or a seal, or feature an engraved or enamelled design. Some rings have sculptural shoulders to join the hoop to the bezel.

Although we have a sense of how rings were worn and owned in the past through portraits, wills and other documents, their makers often remain unknown. Unlike larger pieces of gold or silver, which generally had marks identifying the maker (or the person submitting the piece for official testing and hallmarking) and marks indicating the purity of the metal, jewellery made before the 19th century was not commonly marked. In England the 1738 Plate Offences Act excepted all 'Jeweller's Work' from hallmarking apart from mourning rings (see pp. 69-74). Marking of wedding rings was made compulsory in 1855, although some jewellers might have voluntarily sent work to be marked before then. John Leigh, a London jeweller who successfully defended himself from an accusation of coin clipping (fraudulently removing small quantities of silver from the edge of coins) in 1761, set out the rules on metalworking as he understood them:

As to jewellers' work, there is no act of parliament, nor no rule for a standard, for men to work by, except wedding rings and mourning rings, such we are under an obligation to work standard gold; but for other fancy rings, it is left to the option of the workman: there is no law that binds him to any standard.¹

By the 19th century more stringent hallmarking in Europe brought the identity of the maker into view, although many rings relied on contributions from designers, stone-setters and enamellers, as well as goldsmiths. The great jewellery firms of the 19th and 20th centuries had their own large workshops, but also relied on the assistance of outworkers and small firms. Working in a parallel tradition to that of the jewellery houses, the individual artist-jewellers from the late 20th century onwards gained reputations in their own right.

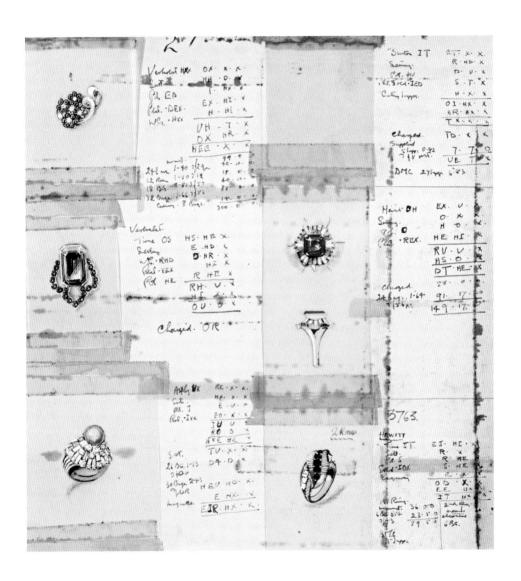

Ledgers from the London firm of H. Godman (later Godman and Rabey), c.1950.

Drawings of the finished pieces sit alongside a coded breakdown of the associated costs and the final price charged to the customer.

 V&A: AAD 2005/1

CHAPTER ONE

1200-1500

Jewellery was more than simply decoration to the medieval wearer. In an age when magic, science and religion were intertwined, a ring could be worn as a sign of faith, as an amulet or to 'cure' illness. The gift of a ring could, as now, signify love or cement social relations. The 13th-century English prelate Bogo de Clare purchased 24 gold rings, probably plain rings - one dozen costing 2s. and the other 2s. 4d. - to be given as thanks for small services rendered.1 The New Year was a traditional time for gifts both personal and official, which were carefully chosen according to the status of the recipient, to affirm allegiances and to promote loyalty. Rings made ideal gifts for these purposes and their hoops were often engraved with New Year's greetings.

In the early Middle Ages lapidaries – texts on the reputed properties of gemstones by ancient Greek and Roman authors such as Theophrastus and Pliny-were rediscovered and translated. Works such as the Liber Lapidum by Marbodus, Bishop of Rennes (c.1035-1123), attributed magical, religious and symbolic powers to various gemstones. Sapphires were often used on episcopal rings, required to be of gold set with an uncut stone, which were given to bishops at their consecration. They were favoured for their celestial blue colour, described by the writer Bartholemeus Anglicus (d.1272) as 'most like heaven in fair weather'.2 Sapphire rings have been discovered in the tombs of several English bishops, including one allegedly found in the grave of William Wytlesey, Archbishop of Canterbury, who died in 1374 (fig. 4).

Rings might be worn in great number for fashionable effect. Portraits from the period show

them on every finger, including the thumb and even the upper joints: in a portrait, Lady Joan Beaufort (c.1379–1440) is shown praying with her daughters, each of whom wears a large number of rings; Lady Joan has five on her right hand alone (fig. 3). Elsewhere, rings are shown worn on strings around the neck, tied to the wrist, pinned to clothes or attached to hats.

Between 1150 and 1400 rings set with sapphires, rubies, garnets or spinels became fashionable. Unfaceted gemstones with polished surfaces, known as cabochons, exploited the natural shape of the stones. In about 1400 the pointcut diamond was developed, using the natural pyramidal structure of the crystal. On one ring from this period the shape of the bezel echoes that of the diamond, tricking the eye into seeing a much larger stone (fig. 9).

The gift of a ring to a lover is a custom known since antiquity. The courtly writer Marie de France wrote in the 12th century: 'If you love him ... send him a girdle, a ribbon or a ring, for this will please him. If he receives it gladly ... then you will be sure of his love.' The author Andreas Capellanus, writing in about 1230 in his treatise *The Art of Courtly Love*, felt that:

A woman who loves may freely accept from her lover the following: a handkerchief ... a ring, a compact, a picture, a wash basin, little dishes, trays, a flag as a souvenir, and to speak in general terms, a woman may accept from her lover any little gift which may be useful for the care of the person or pleasing to look at or which may call the lover to mind, if it is clear in accepting the gift she is free from all avarice.³

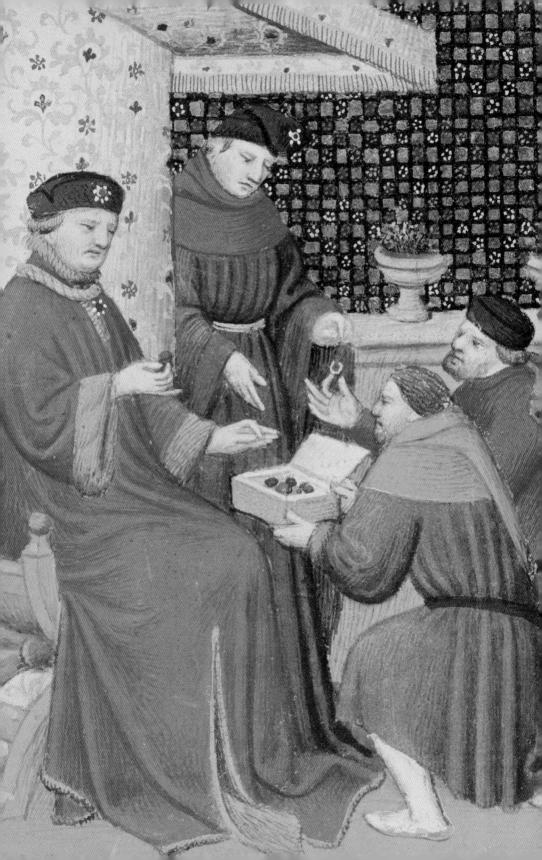

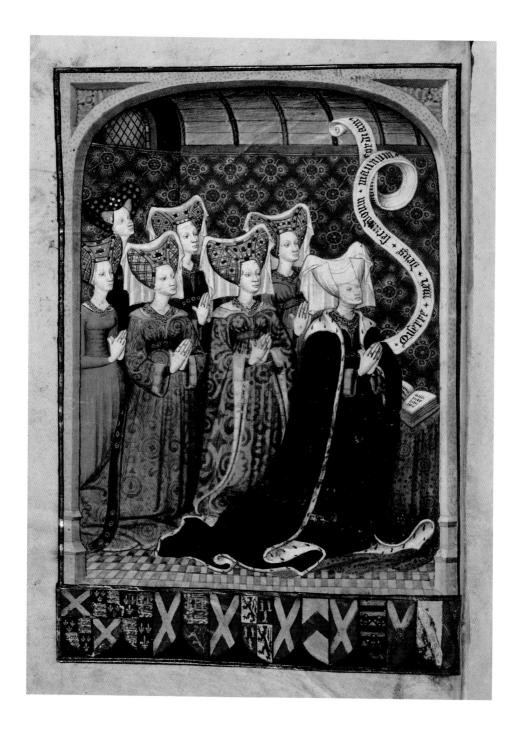

3 Lady Joan Beaufort and her Daughters by an unknown artist, from the Neville Hours. Paris, France, c.1430–40.

Bibliothèque Nationale, Paris

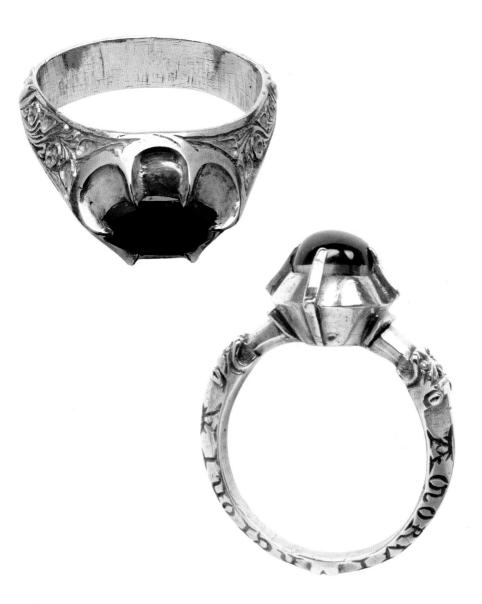

4 Gold ring of Archbishop William Wytlesey, formerly enamelled, set with a pierced sapphire in a claw setting. England, c.1350-70. Inside of hoop inscribed 'Willms Wytlesey'.

V&A: M.191-1975. Given by Dame Joan Evans

5 Gold ring set with a cabochon sapphire in a claw setting. Europe, c.1250-1300. Inscribed Amor vincit omnia ('Love conquers all'), a common inscription taken from the Roman poet Virgil's Eclogues, and Ave Maria Gra[cia] (an abbreviation of 'Hail Mary, full of Grace', a prayer to the Virgin Mary).

V&A: M.181–1975. Given by Dame Joan Evans

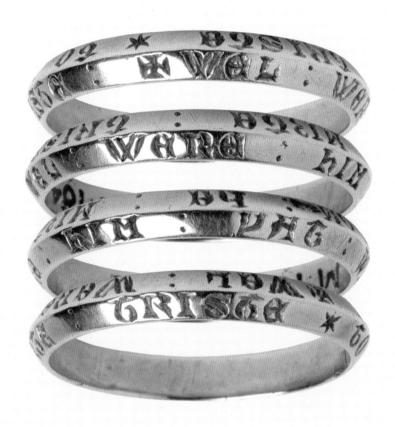

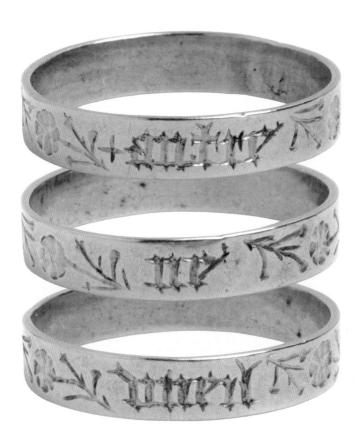

- 8 Gold ring set with a cabochon sapphire. Europe, c.1200-1300. Decorated with chased leaves and dragon heads, its 'stirrup' shape is characteristic of the 13th century. V&A: M.183-1975. Given by Dame Joan Evans
- 9 Gold ring set with a diamond. Europe, c.1400. Shoulders inscribed Ave Maria. Half of an octahedral crystal has been set as a natural diamond point, polished but not faceted. V&A: M.188-1975. Given by Dame Joan Evans
- 10 Gold ring set with a cabochon sapphire. England or France, c.1200–1300. The setting allows the sapphire to stand proud of the hoop and catch the light. The flaws in the surface have been polished but it remains pockmarked.

V&A: 645-1871

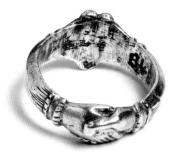

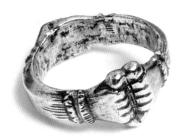

Diamond rings were often exchanged at betrothals or weddings. Symbolically they combined the strength and unbreakable quality of the stone with the never-ending circle of the ring. A priest's manual, written by Guillaume Durand in the 13th century, describes the diamond as 'unbreakable and love unquenchable and stronger than death, so it suits [the diamond ring] to be worn on the ring finger, the vein of which comes directly from the heart', an idea taken from Roman authors (see p. 33).⁴

Romantic inscriptions known as 'posies', often written in French or Latin, the languages spoken by educated people across Europe, decorate many medieval rings. While some posies were obviously common phrases, others have a more personal feel. The motif of two hands clasped in love, known as a 'fede' from the Italian mani in fede (meaning 'hands [joined] in trust', inspired by the Roman device of dextrarum iunctio, or 'clasped right hands'), also appears regularly on medieval jewellery (fig. 11). It was a sign of loyalty and commonly associated with betrothals.

Rings with religious designs or engravings of saints were often worn in the Middle Ages.

Individuals might choose a ring bearing an image of the saint whose name they shared, or because of the belief that each saint could protect against a particular mischance. Appealing to saints was considered to bring prosperity, safety from enemies both physical and spiritual, healing from disease, protection in childbirth and a 'good death' comforted by the sacraments. St Sebastian, for example, was believed to protect against the plague, while St Christopher kept travellers from harm. St Anthony, whose emblem was the Tau cross (fig. 17), was thought to guard against ergotism or 'St Anthony's fire', a form of poisoning caused by eating rye infected with the ergot fungus. St Margaret, who, according to legend, sprang unharmed from the belly of a dragon, was sought to strengthen women in labour, and St Barbara and St Katherine to quard against sudden death during childbirth, a common occurrence during the Middle Ages. Girdles or prayers written on rolls of parchment worn around the abdomen were believed to protect women while pregnant and in labour, and a number of rings survive that are shaped as buckled belts or girdles (fig. 18). Thought to be pilgrims' souvenirs, these rings may relate to shrines of the Virgin Mary, whose girdle was venerated at Padua and Le Puy.

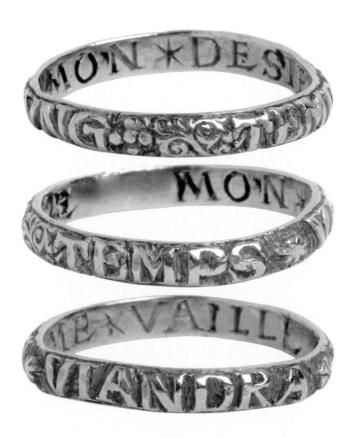

12 Gold ring (three views). Possibly France, 1500–30. Outside of hoop inscribed *Ung temps viandra* ('A time will come'); the inside *Mon désir me vaille* ('My longing keeps me awake').

V&A: M.221–1962. Given by Dame Joan Evans

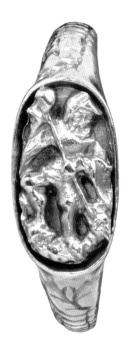

13 (left) Gold ring engraved with the Trinity and two saints.

England, 1400–1500. Inside of hoop inscribed *En bon an ('A good year')*.

V&A: M.241–1962. Given by Dame Joan Evans

14 (right) Gold ring with a relief of St George and the dragon. England, 1350–1400. Shoulders inscribed *Nul si bien ('N*one so fine'). V&A: M.235-1962. Given by Dame Joan Evans

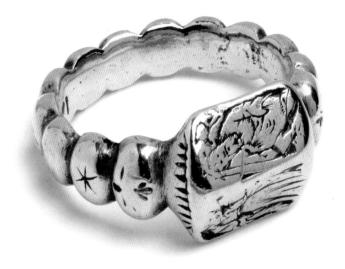

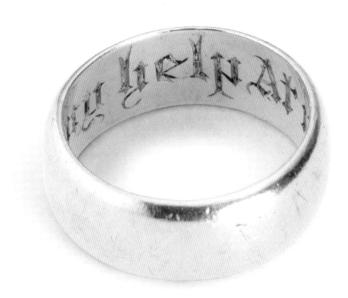

15 Gold ring. England, 1400–1500. Bezel engraved with St Barbara and St Christopher; hoop inscribed *A ma vie* ('For my life'). The 13 bosses around the hoop may have been used to count out prayers, as is done with a rosary.

V&A: 690–1871

16 Gold ring inscribed 'God be my help at nede'. England, 1400–1500. V&A: M.66–1960. Given by Dame Joan Evans

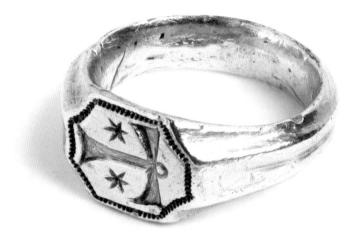

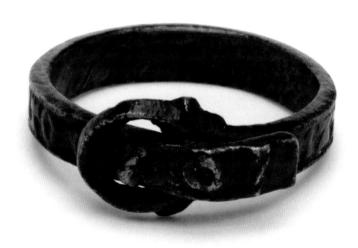

17 Silver ring engraved with a Tau cross. Germany, 1500–1600. V&A:779-1871

18 Bronze ring inscribed *Mater Dei memento [mei]* ('Mother of God, remember [me]'). Europe, 1400–1500. V&A: M.225-1962. Given by Dame Joan Evans

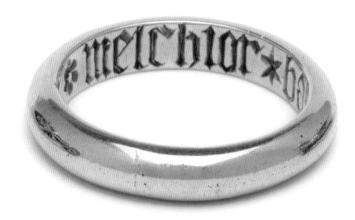

19 Gold ring set with a wolf's tooth. England or France, 1200–1300.

A later inscription inside the hoop (c.1400) reads *Buro + Berto + Berneto +*Consumatum est, a magical invocation against toothache and storms.

V&A: 816–1902

20 Gold ring. England, 1400–1500. Inscribed with the names of the Biblical Three Kings, Caspar, Melchior and Baltazar. V&A: M.91–1960. Given by Dame Joan Evans

Daily prayers and the reading of devotional books such as breviaries, primers and books of hours framed the day for individuals who keenly sought protection against the trials and dangers of daily life, and the machinations of spiritual enemies. One common belief held that virtue could be acquired by touching rings against a holy relic or shrine. The 15th-century Dominican friar Felix Faber took a bag of rings and beads belonging to friends to the Holy Land, intending to touch every shrine and relic he encountered with them so that 'they may perchance derive some sanctity from the touch'. 5 Belief in the power of rings existed at the highest level of society. In 1482 the episcopal ring of St Zenobius (337-417), the first Bishop of Florence, was sent from Florence to the ailing King Louis XI of France (1423-83) to cure his persistent headaches and a skin disorder feared to be leprosy.6

Contemporaries believed that a ring's power could be magnified by inscribing protective words and phrases upon the hoop. The Three Kings of the Bible, whose relics are housed in a

shrine in Cologne Cathedral, were thought to protect the wearer against epilepsy or the 'falling sickness' (fig. 20). As the inscription on a 14th-century brass vessel explains, 'Caspar bore myrrh, Melchior frankincense, Balthazar gold. He who bears with him the name of the Three Kings is freed, through the Lord, from the falling sickness.' Invocations combining both orthodox religion and magic were common inscriptions on rings. The power attributed to them is explained in this invocation from a book of hours of 1536:

Omnipotens + Dominus + Christus + Messias + Sother + Emanuel + Sabaoth + Adonay + ...
Clemens + Caput + Otheotocos +
Tetragrammaton + May these names protect and defend me from all disaster and from infirmity of body and soul, may they wholly set me free and come to my help ... May they assist me in all my necessities and defend and liberate me from all dangers, temptations and difficulties of body and soul, and from every evil, past, present and future, keep me now and in eternity.8

21 Gold ring. Italy, 1300-50. Bezel engraved with a merchant's mark and the name Galgano d'Chicho; hoop inscribed lesus autem transiens per medium illorum ibat ('But Jesus passing through the midst of them went His way'; Luke IV.30), a Biblical verse thought to protect travellers from robbers, which is often found on purses and ring brooches (circular brooches with pins).

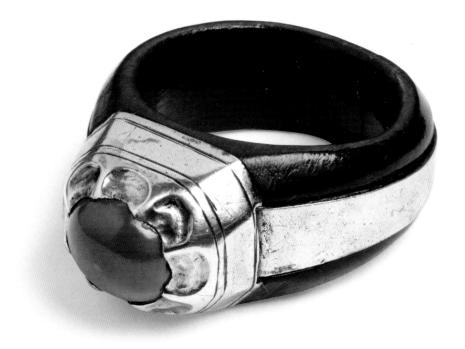

On one ring, the words *Buro, berto, berneto* were inscribed as a magical charm against toothache, increasing the prophylactic power of the wolf's tooth set in it (fig. 19). The same ring bears the inscription *Consumatum est* ('It is finished'), the last words spoken by Jesus on the Cross, which was thought to calm storms at sea and protect the voyager.

Due to its amuletic properties, toadstone was valued as highly as gemstones, despite its drab appearance (fig. 22). So called because it was believed to emanate from a toad's head, toadstone is, in fact, the fossilized tooth of a prehistoric fish. In 1582 the English translator and author Stephen Batman described it as efficacious against the bite of spiders and 'creeping worms' and valuable because 'in presence of venimme [venom], the stone warmeth and burneth his finger that toucheth him'.9

Rings also served official purposes: signet rings, featuring either engraved bezels or bezels set with intaglios (carved gemstones), were pressed into warm sealing wax to authenticate

documents. Coats of arms, initials, personal devices or merchants' marks, stamped upon bales to identify their goods, could all be employed as designs on such rings, and wax seals imprinted by signet rings survive on many documents, testifying to their widespread use.

The tradition of mounting intaglios on jewellery continued through the Middle Ages with ancient or Byzantine gemstones featuring incized or engraved classical motifs often incorporated into rings (fig. 25). High-quality ancient gems, possibly from Rome or Venice, were traded across Europe and sometimes also set in church metalwork or used as personal seals. A 14th-century Italian ring owned by Thomas de Rogeriis de Suessa is set with a Roman intaglio of two clasped hands (fig. 27). The subject of the classical gemstone was sometimes appropriated to serve new purposes: wearers may have interpreted a Roman emperor as a saint, or a Hellenistic princess as the Virgin Mary. However, individuals versed in classical literature would have understood the original motif.

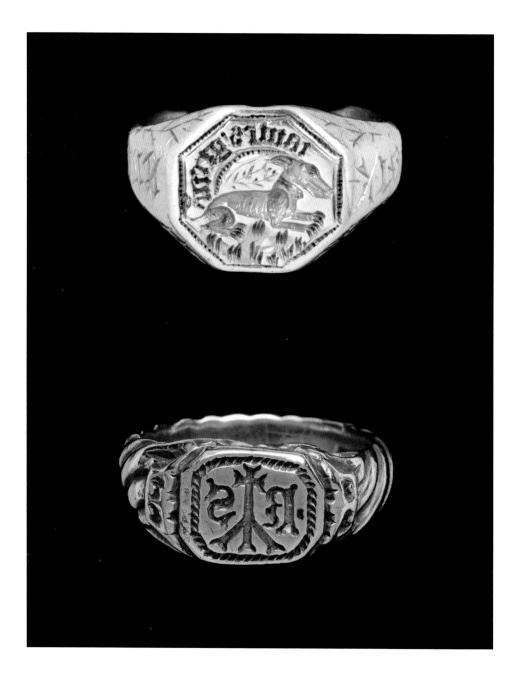

23 Silver ring, Western Europe, 1400–1500. Inscribed 'James Grew' and an image of a greyhound. Dogs symbolized loyalty and this may have been a personal device.

V&A: 143-1907

24 Gold ring. England, 1400–1500. Engraved with a merchant's mark and the initials 'RS'.

V&A: M.203–1975. Given by Dame Joan Evans

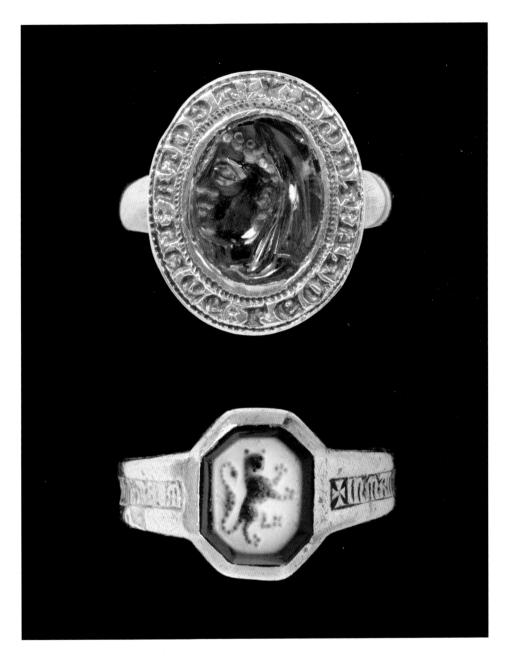

25 Gold ring set with a Greek sapphire intaglio of a veiled woman (c.100 BCE). England or France, c.1300. Inscribed *Tecta lege*, *lecta tege* ('Read what has been written, hide what has been read'), a phrase often found on seals of this period.

V&A: 89-1899

26 Gold ring set with a nicolo intaglio. Italy, 1300-50. The heraldic lion rampant on the bezel is coupled with words spoken by Jesus on the Cross, commonly found in prayers for the dying: In manus tuas Domine comendo spiritum meum ('Into your hands, O Lord, I commend my spirit').

V&A: M.190-1975. Given by Dame Joan Evans

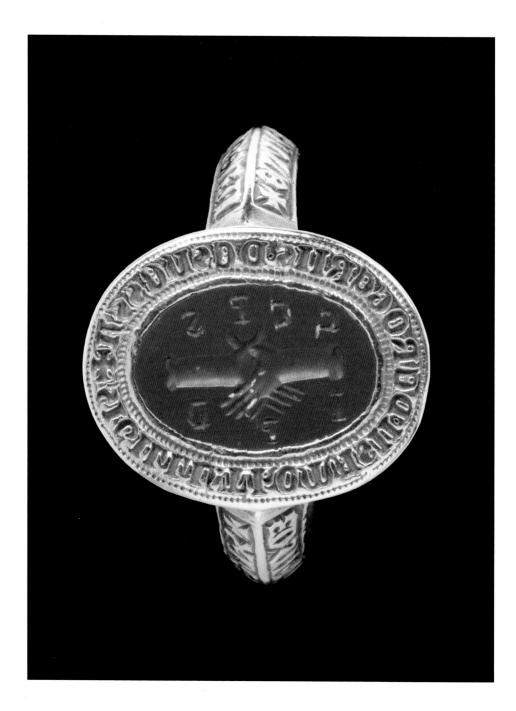

27 Gold ring set with a Roman jasper intaglio inscribed with the initials 'CCPS' and 'IPD' (200-300 CE). Italy, c.1300-50. Bezel inscribed 'Thomas de Rogeriis de Suessa'; hoop inscribed Christus vincit, Christus regnat, Christus imperat ('Christ conquers, Christ reigns, Christ rules') and Et verbum caro factum est et habitavit in nobis ('And the Word was made flesh and dwelt among us', John 1.14).

V&A: M.275-1962. Given by Dame Joan Evans

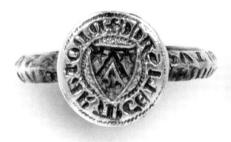

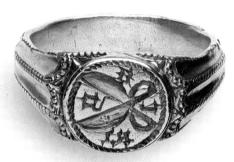

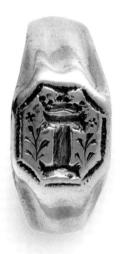

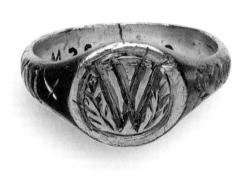

28 (above, left) Silver ring. Italy, 1300–1400. Engraved with a shield and inscribed '+n notar angelis ACC' and Mortuus fueram arevit perieram et inventus sum ('I was dead, I was brought to life. I was lost and I was found').

V&A: 805–1871

29 (above, right) Silver ring. Probably Germany, 1400–1500. Engraved with a pair of open shears and an inscription possibly reading 'Grace'. It probably belonged to a member of a tailors' guild. V&A; M.258–1962. Given by Dame Joan Evans

30 (below, left) Silver ring. England, 1400–1500. Engraved with a crowned 'I', probably the owner's initial.

V&A: 1374–1903

31 (below, right) Silver ring. England, 1450–1550. Engraved with the initial 'W' and inscribed 'God x help x williem'.

V&A: M.256–1962. Given by Dame Joan Evans

CHAPTER TWO

1500-1700

Renaissance rings

The simple shapes of medieval rings were transformed into the triumph of Renaissance goldsmiths, as cartouches, scrolls, foliage, classical masks and colourful enamels came to adorn their creations. Artists were inspired by the surviving ruins, statues and carved gemstones of the Greek and Roman world and aimed to incorporate the principles of classical art into new works. Cusped bezels became the enamelled quatrefoils seen on so many portraits of the time (fig. 40). Rings were set with rubies, diamonds, sapphires or emeralds, and improving or altering the colour of the gemstone by placing a tinted foil behind it became a common practice: the Italian goldsmith Benvenuto Cellini (1500-71) recorded recipes for creating different shades in his treatise on the art of jewellery. Printed ornamental drawings by artists such as Pierre Woieriot, Réné Boyvin, Daniel Mignot and Etienne Delaune show the heights of fantasy to which the goldsmith might aspire (fig. 35). Goldsmiths also took inspiration from the art of ancient Greece and Rome, copying classical motifs and figures. A delicately carved intaglio of Medusa on one ring is a fine example (fig. 33).

Renaissance portraits and contemporary texts suggest that both men and women wore rings in profusion, from palm to fingertip; sometimes rings even peeped through the slashed fabric of gloves. In 1515 the Venetian ambassador to England described the hands of King Henry VIII (1491–1547) as 'one mass of jewelled rings'.' While many rings were made of gold or silver, cheaper base metal alternatives were available to those with more modest purses. Children also wore rings in smaller versions of adult styles. A tiny diamond ring, which must have

belonged to a very young child, was inscribed 'this spark will grow', a wish for the health and long life of its wearer (fig. 38). Another small example was set with turquoise, believed to be a talisman that both protected the wearer and indicated the state of his or her health, making it an especially appropriate gemstone for a child's ring (fig. 39). The stone was described by the poet John Donne (1572–1631) as 'a compassionate turquoise that doth tell/by looking pale the wearer is not well'.²

The magical properties of rings

The distinction between science and magic remained hazy during this period. Belief in the theory that illness was caused by an imbalance between hot, cold, wet and dry 'humours' in the body, and in the sympathetic properties of inanimate objects, made possible a continuing faith in the powers of gemstones. Rings were also regarded as inherently magical. In 1546 Henry, Lord Neville, was imprisoned for commissioning a ring to guarantee success with the dice at the gambling table.3 In 1580 the courtier Sir Christopher Hatton sent a ring to Queen Elizabeth I of England (1533-1603) 'which hath the virtue to expel infectious airs'.4 The unbroken circle of the ring was likewise believed to be of powerful assistance in the conjuration of demons.

Gemstones were selected for their significance as well as their colour and dazzle. A 16th-century gold ring set with turquoise, and with the initials 'FDA' and a winged heart formed from gold openwork, may have been a love gift (fig. 41). In addition to being a talisman, turquoise, according to the old belief expressed in Thomas Nichol's lapidary of 1659, was 'likewise said to take away all enmity, and to reconcile man and

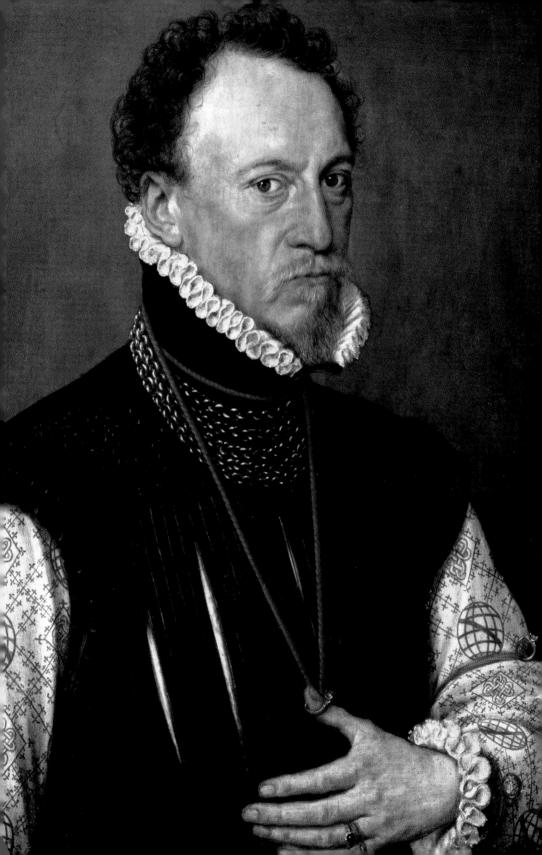

wife', and was therefore suitable for a romantic gift.⁵ In *Li nuptiali*, written in about 1500, the Roman author Marco Antonio Altieri explained the appeal of setting both sapphires and rubies in a love ring:

The sapphire is sky blue in colour, and denotes our soul, which derives from it; and then the balas [ruby], made of fiery matter denotes the body, receptacle of the heart, burning with amorous flame and for this reason [this type of ring] represents the gift of both the soul and the heart.⁶

Wedding rings

Almost any gem-set, gimmel (see p. 41) or posy ring might have served as a wedding ring in the 15th century, but, following existing tradition, a diamond ring remained the first choice for those who could afford one. The ring's circular

form, a symbol of eternity, was paired with a seemingly indestructible gemstone to express the hope for an eternal union. A manuscript in the Vatican, recording the marriage of the Italian nobleman Constanzo Sforza and Camilla D'Aragona in 1475, shows nuptial torches (used to celebrate a wedding) threaded through a diamond ring under the inscription: 'Two wills, two hearts, two passions are joined in marriage by a diamond ring.'

A description of the deathbed of Lady Catherine Grey (1540–68), the granddaughter of Henry VIII's sister Mary Tudor, illustrates how fluid contemporary views of the wedding ring were. Entrusting her jailer, Sir Owen Hopton, with her rings, she:

Took out a ring with the pointed diamond and said, 'Here, Sir Owen, deliver this unto my Lord.

This is the ring I received of him when I gave myself to him and gave him my faith.' When asked whether this was her wedding ring, she replied, 'No, Sir Owen, this was the ring of my assurance unto my Lord. And here is my wedding ring', taking another ring all of aold out of the same box.⁸

In this account, Lady Catherine distinguishes the diamond ring given to her at her betrothal from her gold wedding ring, which was presumably used in her marriage service in 1560. (Her wedding to Edward Seymour, Earl of Hertford, was held in secret and, as a potential successor to her cousin Elizabeth I, she was imprisoned until her death.) Although the Anglican Book of Common Prayer (1559) does require that a ring be exchanged in the marriage service, it does not specify which metal should be used. Some English Puritans condemned the use of wedding rings as 'superfluous and superstitious',

associating their use with Catholicism, but King James I (1566–1625) confessed in 1604 that he 'was married withall, and added that he thought they would prove to be scarce well married who were not married with a ring'.

The fourth finger was the most usual place for the wedding ring. A longstanding belief, derived from the Roman authors Aulus Gellius and Macrobius, held that a vein ran directly from the heart to the fourth finger of the right hand so that 'rings hereon peculiarly affect the heart'. By 1549, however, the Book of Common Prayer, published in the reign of King Edward VI (1537–53), specified the use of the left hand for weddings. In 1646, discussing the former use of the right hand, the English author and polymath Sir Thomas Browne considered that tradition to have been based upon a 'vulgar error', or mistranslation, and that Macrobius had been speaking of the left hand all along. 11

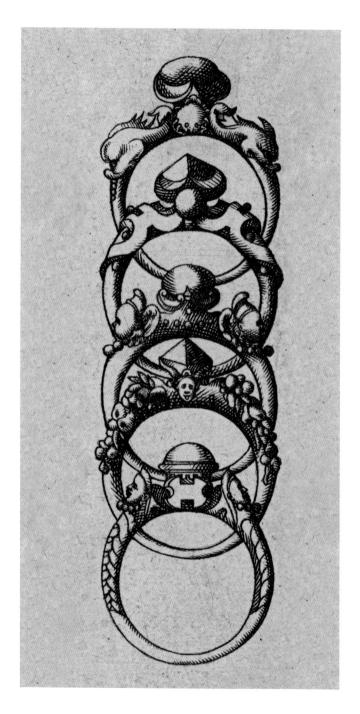

35 Designs for rings from *Le Livre de bijouterie*, engraved by Réné Boyvin after Rosso Fiorentino or Léonard Thiry. Paris, France, c.1600. The plate shows rings in the style of the 1530s, set with cabochon and point-cut gemstones.

V&A: E.397-1926

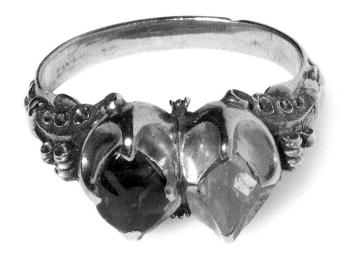

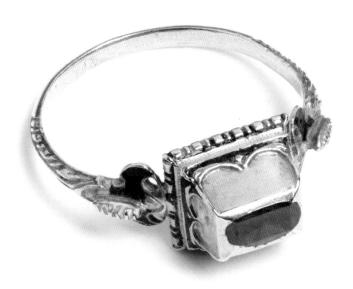

36 Enamelled gold ring set with a ruby and a diamond. Germany, c.1500.

V&A: M.1–1959. Given by Dame Joan Evans

37 Enamelled gold ring set with a table-cut pink sapphire. Europe, c.1550-1600. V&A: 731-1902

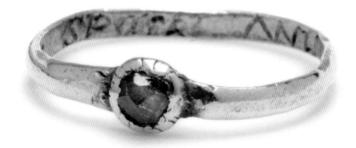

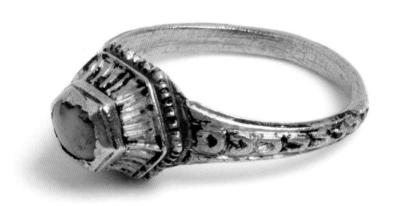

Gold ring for a child, set with a diamond and inscribed 'this spark will grow'. England, 1600–1700.

V&A: 908–1871

Enamelled gold ring for a child, set with turquoise.

Europe, 1500–1600.

V&A: 955–1871

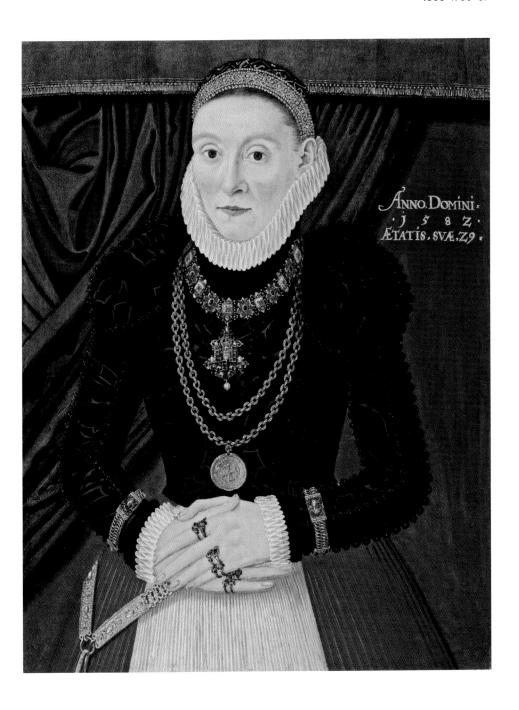

40 A Young Woman Aged 29 by an unknown artist. Possibly southern Germany, 1582. A fashionably dressed young woman shows off her gem-set rings with enamelled quatrefoil settings.

V&A: 4833-1857

41 Gold ring set with turquoise. Possibly Germany, 1550–1600. V&A: M.2–1959. Given by Dame Joan Evans

42 Enamelled gold ring set with a diamond. Europe, c.1550–1600. V&A: 730–1904

43 Designs for rings from Pierre Woeiriot's *Livre d'aneaux d'orfèvrerie*. Lyon, France, 1561. V&A National Art Library, press mark 210. A.33

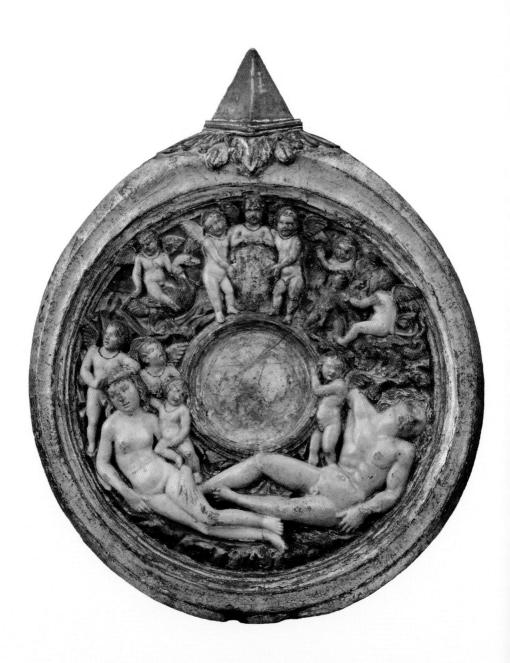

44 Mirror frame in the form of a diamond ring. Painted and gilded stucco in a gilt frame, in the style of Antonio Pollaiuolo. Italy, 1470–80. The Florentine banker Cosimo de' Medici (1389–1464) used the diamond ring as an emblem, as did later members of the family.

V&A: 5887-1859

Gimmel and posy rings

Gimmel rings, from the Latin gemellus (twin), in which the hoop divides into two or sometimes three parts, were often decorated with clasped hands and hearts. Their use in weddings is suggested by the inscription of phrases used in marriage services inside the hoops (fig. 46). The financier Sir Thomas Gresham (c.1519-79), founder of London's Royal Exchange, is said to have been married in 1544 with a gimmel ring, one hoop of which was marked Quod Deus conjusit ('What God has joined together') and the other Homo non separet ('Let man not set aside').¹²

The name 'posy ring' is taken from the word 'poesy' or poetry. A short romantic verse was engraved within the hoop and suggests they were used for betrothals or weddings. The inscription of stock posies was a regular practice: a London jeweller asked to identify a wedding ring inscribed 'God alone made us two

one', stolen in a gruesome murder in 1737, statedthat 'As to the Motto of the Ring, 'tis a common one, and there may be 500 such Rings about the Town'. 13 Compendiums, such as Love's Garland, or Posies for Rings, Handkerchers and Gloves and Such Pretty Tokens as Lovers Send their Loves (1674), offered lists of posies or 'epigrammes' to be placed on personal items. In 1738 one young squire entertained his lady 'with Ends of Verses, which he had got by Heart from the Academy of Compliments'.14 This useful publication, first published in 1639, was known as The Academy of Complements [sic] with Many New Additions of Songs and Catches a la mode with [a] Variety of Complemental and Elegant Expressions of Love and Courtship. More literate or imaginative buyers could supply their own text. The English diarist Samuel Pepys (1633-1703) and his family once sat composing a posy for his cousin Roger Pepys's wedding ring while waiting for their lamb to roast.

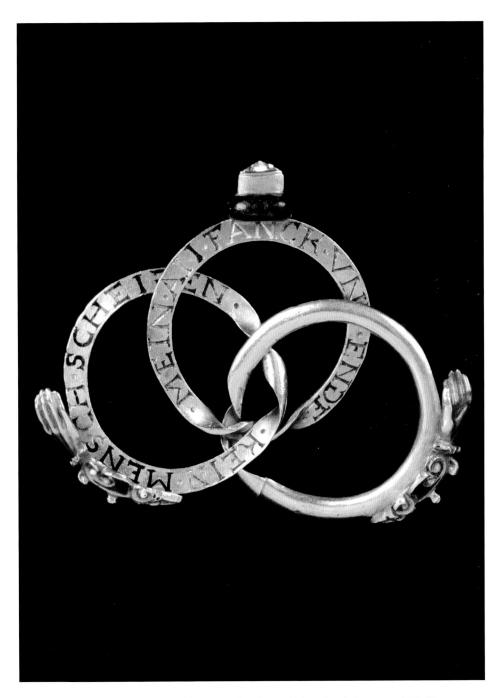

46 Triple-hoop enamelled gold ring set with a diamond (three views). Germany, c.1600-50. Inscribed Mein anfanck und ende ('My beginning and my end') and Was Gott zusamen fuget soll, kein mensch scheiden ('What God has joined together, let no man put asunder'), phrases used in marriage services.

V&A: M.224-1975. Given by Dame Joan Evans

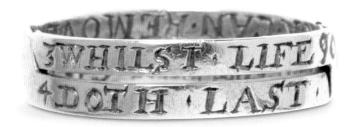

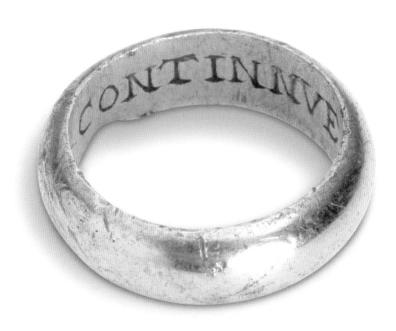

47 Gold ring. England, 1600–1700. Inscribed 'Accept this gift of honest love which never could nor can remove' and '1. Hath tied 2. mee sure 3. whilst life 4. doth last'.

V&A: 909-1871

48 Gold ring. England, c.1600. Inscribed 'Continnue faithfull'. V&A: M.69-1960. Given by Dame Joan Evans

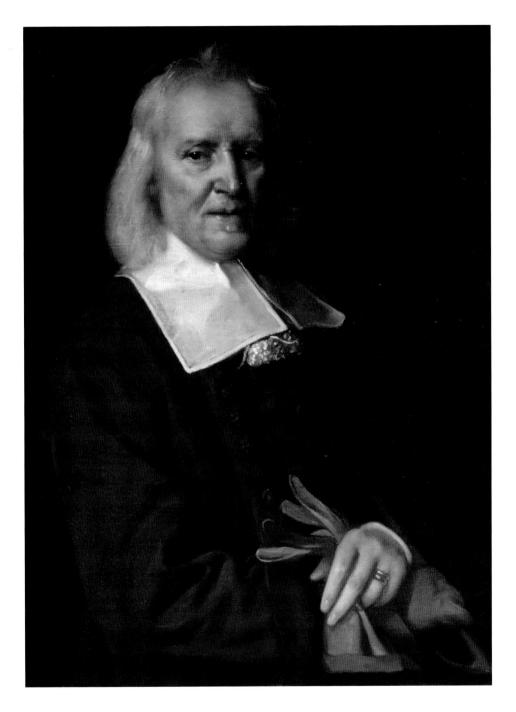

49 *Izaak Walton* by Jacob Huysmans. England, c.1672. Walton wears two plain gold rings on his wedding finger, having married again shortly after his first wife's death in 1640.

National Portrait Gallery, London

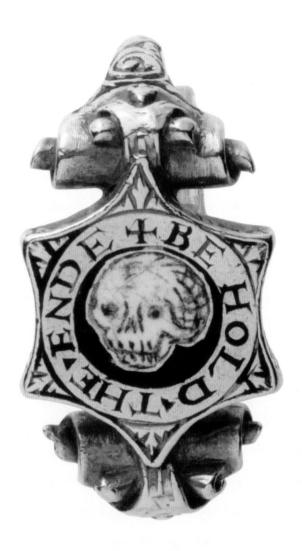

50 Enamelled gold ring with a death's head. England, 1550–1600. Bezel inscribed 'Behold the ende', its edges inscribed 'Rather death than fals fayth', and its reverse bearing the initials 'ML', connected by a true lover's knot. This ring may have served both as a *memento mori* and a wedding ring.

V&A: 13-1888

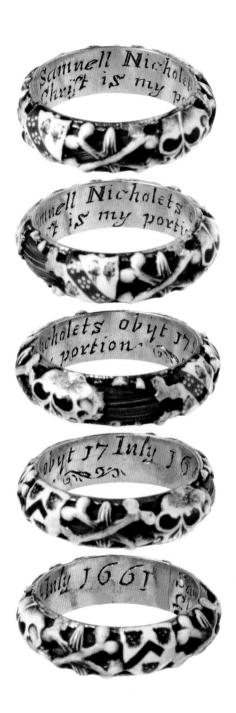

51 Enamelled memorial ring (five views). England, 1661. Inscribed 'Samuell Nicholets obyt 17 July 1661. Christ is my portion'. Hoop pierced to reveal a band of hair and decorated with skulls, crossbones and the arms of the Nicholets family. V&A: M.156-1962

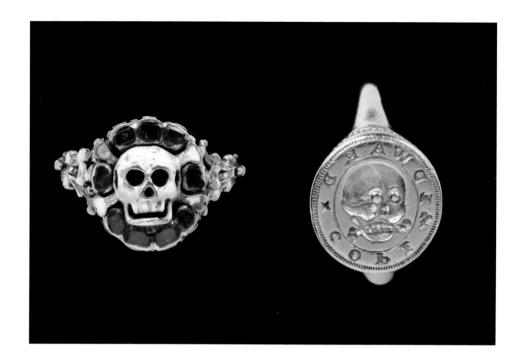

Memorial rings

Rings could serve as reminders of death. Memento mori ('Remember you must die') rhetoric and imagery was found in poetry, in paintings and on rings, and stressed the inevitability of death:

I am but worms meat, wel I wot, All Fleasch is nowt but gras To earth and ashes out of hand Must all my pleasures pass.¹⁵

Skulls, skeletons, hourglasses and worms reminded the true Christian of the need to prepare for death and judgment. To the preacher Robert Hill, writing in 1610, it was 'the art of all arts, and the science of all sciences to learn to die'. Memento mori rings were worn as daily reminders of death, and were sometimes set with a revolving bezel: an image of a skull was hidden behind a signet as a private

message to the wearer of the truly important things in life. One such ring has a piece of bone set in the underside of the bezel, which may be a relic or simply a tangible reminder of death (fig. 53). Rings engraved with skulls were evoked in Falstaff's plea in William Shakespeare's Henry IV, Part 2: 'Do not speak like a death's head; do not bid me remember mine end '17

Memento mori rings were sometimes given as memorial rings to commemorate an individual, but by the end of the 17th century the symbols of death were found less frequently. Instead, memorial rings inscribed with the name and the date of death of a friend or relative became customary, and wills specified sums to be spent on buying memorial rings for legatees. Shakespeare's will of 1616 left 26s. 8d. apiece to buy rings for four of his fellow townsmen and three actors.

52 Enamelled gold ring set with rubies. Europe, 1550–75. V&A: M.280-1962. Given by Dame Joan Evans

Favours distributed at funerals and weddings often included rings, gloves and ribbons. Samuel Pepys attended the burial of Captain Robert Blake at Wapping in 1661, and recorded in his diary that they 'had each of us a ring, but it [the weather] being dirty, we would not go to church with them, but with our coach we returned home'. In 1685 Sir Ralph Verney reported that:

Sir Richard Piggott was buried very honourably and at a considerable charge, with two new Mourning Coaches and a [six-horse] Hearse. We that bore up the pall had Rings, Scarfs, Hat-Bands, Shamee Gloves of the best fashion ... the rest of the Gentry had Rings and all the Servants Gloves. ¹⁹

At the funeral of his five-year-old son in January 1658, the English writer and diarist John Evelyn was accompanied by 'divers of my relations and neighbours among whom I distributed rings with this motto "Dominus Abstulit" ["The Lord hath taken away"]', a quotation from the Book of Job.²⁰

Rings, personal motifs and symbols of loyalty

As well as performing symbolic roles, rings of this period continued to serve practical purposes. Signets remained an essential part of daily business, many made of plain metal with a coat of arms, entwined initials or an appropriate symbol. Finds from field archaeology, and those reported via the Portable Antiquities Scheme in England and Wales since 1997, have brought many more such rings to light; the heavy gold signet ring (c.1580; fig. 58) recorded as having been found 'on the tooth of a harrow' in about 1800 is engraved with the arms of the Boteler family of Kent. In an age before widespread literacy, personal marks were

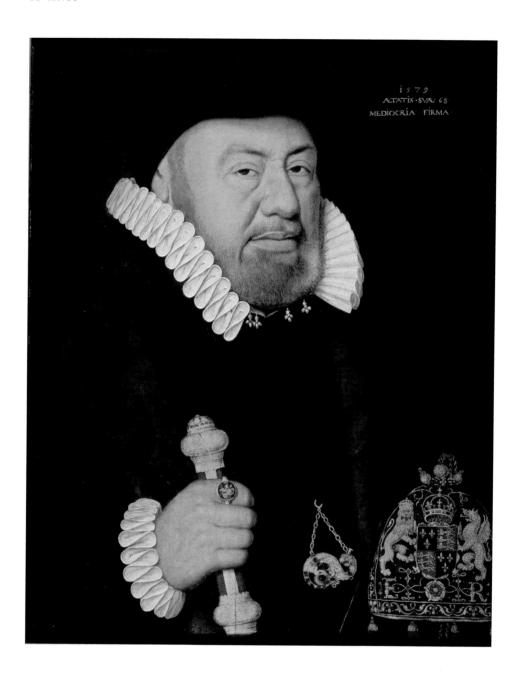

55 *Sir Nicholas Bacon* by an unknown artist. England, 1579. Private Collection/Bridgeman Images

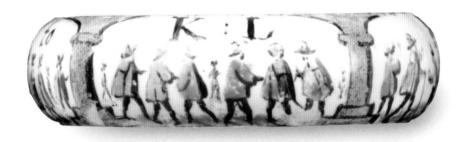

an important part of everyday life. Marks similar to those used by merchants to identify their goods were found on sailors' belongings in the wreck of the *Mary Rose*, the flagship of Henry VIII, which sank in 1545 and was recovered in 1982.

Coats of arms were carved into translucent crystal or hardstone, placed over painted foil and set in rings worn by people of high status. Henry VIII is known to have given rings carved with his portrait to courtiers and loyal subjects (fig. 59). In most surviving examples damp has corroded the bright colours of the foils, but portraits such as that of Sir Nicholas Bacon (1510–79), a courtier during the reign of Elizabeth I, illustrate their original appearance (fig. 55). He is shown holding a staff of office and wearing a signet ring with a brightly painted coat of arms. Sir Thomas Gresham

distributed a group of similar foiled crystal rings to his friends and business associates, engraved with their arms and, on the underside of the bezel, enamelled with a grasshopper derived from his crest (fig. 57). The conjunction of Gresham's crest and the arms of his associates must have served to underline the bonds between them, with the gift and wearing of the ring linking donor and recipient. An enamelled gold ring from the town of Totnes, Devon, was also a gift, in this case one of a pair commissioned by the town in 1652 to mark the payment of a debt and to commemorate the building of an arcade for the town's merchants. The finely painted enamel shows the merchants conversing under the columns of the arcade. The rings were given to the sisters Katherine and Christian Lee and passed down through their families for 400 years (fig. 56).

56 Enamelled gold ring. England, c.1652. The hoop is inscribed 'RL to T and T to KL'. This ring was a gift from the town of Totnes, Devon, to Katherine Lee ('KL') to mark the building of the town's merchant exchange, financed by her grandfather Richard Lee ('RL').

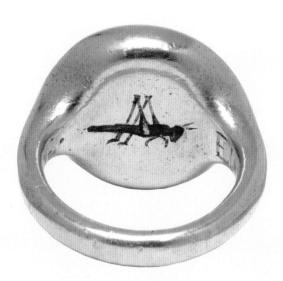

57 Gold ring (two views) set with a reverse-painted and gilded chalcedony intaglio, engraved with the arms of Sir Richard Lee and inscribed 'Flame et fame'. England, c.1554-75. The back of the bezel is enamelled with a grasshopper, the personal device of Sir Thomas Gresham.
V&A: M.249-1928. Bought with funds from L.C.G. Clarke

58 Gold signet ring with coat of arms of the Boteler family. England, about 1580. Engraved 'Do not for to repent', suggesting that the wearer should not act wrongly for fear of regretting the consequences.

M.99-1984

59 Gold ring set with a chalcedony intaglio engraved with a portrait of Henry VIII. London, England, 1545-75. An impression of the intaglio survives on a document sealed by Dorothy Abington, wife of the Queen's Cofferer, an administrator in the royal household, in 1576.

V&A: M.5-1960. Bequeathed by Mrs Ann Cameron

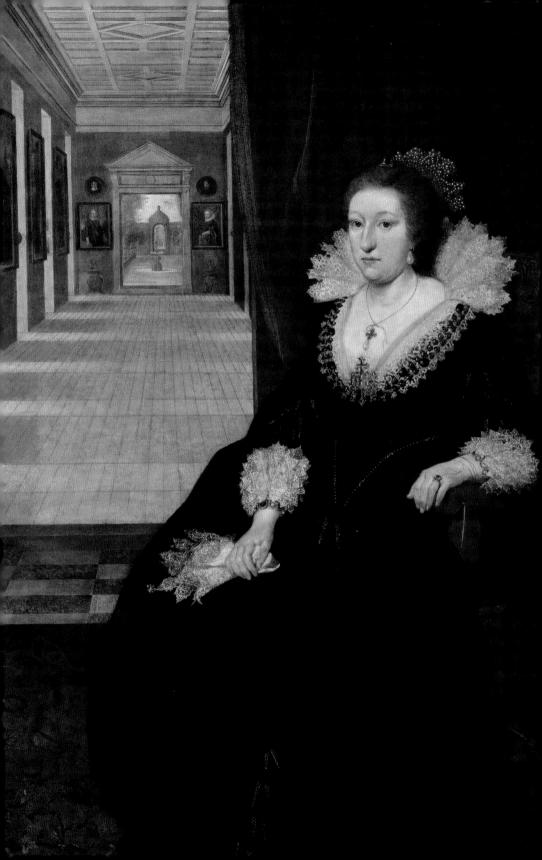

Loyalty to the executed King Charles I (1600–49) was expressed through rings and other jewellery set with his portrait, ranging in quality from very fine jewels to plainer objects. Although some were worn during the English Civil War (1642–51), many were made after the restoration of the monarchy in 1660, and continued to be collected and worn by supporters of the exiled King James II (1633–1701) and his family in the 18th century. A fine emerald ring inscribed with the crowned monogram of James II was said to have been given by the King to his chaplain (fig. 61).

Participation in the machinery of the state prompted the gift of rings. Serjeants at law, the most senior members of the English judiciary beneath judges, were required to present rings to the monarch and officers of the courts upon their appointment. The first recorded mention of this custom was in 1368, when Thomas Morice 'gave gold in the Lord King's Court'. These rings were customarily made of plain gold and engraved with a fitting legal or patriotic motto. The custom ceased in 1875 when judges were no longer required to have served as serjeants.

60 (left) Alathea, Countess of Arundel and Surrey (detail) by Daniel Mytens. England, c.1618. The Countess is shown wearing a ring tied to her wrist by a black thread, both a fashionable and a practical custom. National Portrait Gallery, London

61 (above) Gold ring set with an emerald and table-cut diamonds. England, 1685–1701. The back of the bezel is engraved with the monogram of James II.

V&A: M.10-1970. Given in memory of Martin Buckmaster

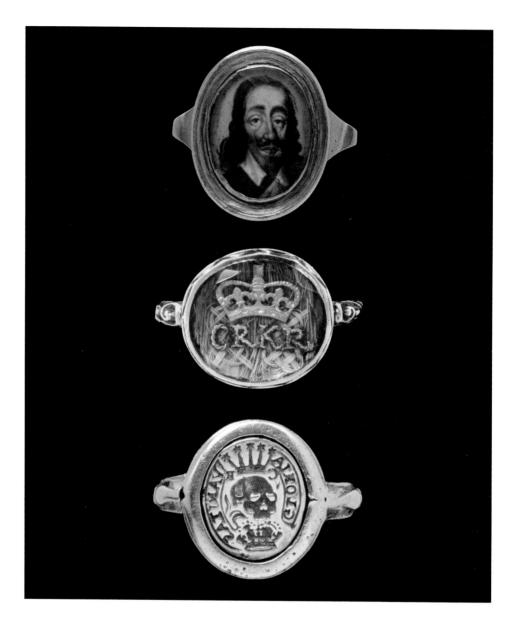

62 Gold ring commemorating King Charles I, with a miniature (c.1649–1700) set under rock crystal. England, c.1780.

V&A: M.1–1909

- 63 Enamelled gold memorial ring for Charles II and his queen, Catherine of Braganza, with woven hair and gold wire set under rock crystal. England, 1685–1705. Charles II died in 1685 but the ring may have been made after Catherine's death in 1705.
 V&A: 927-1871
- **64** Enamelled gold memorial ring. England, c.1649. Revolving bezel inscribed *Gloria*, and *Vanitas* with the initials 'CR', and, on its reverse, set with an intaglio portrait of Charles I. Hoop inscribed 'IA: the 30/1648' and *Emigravit Gloria Angl* ('The glory of England has departed').

 V&A: M.274-1962. Given by Dame Joan Evans

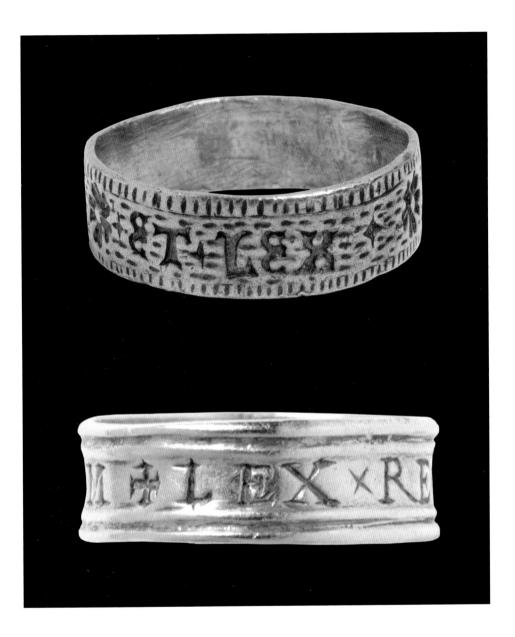

65 Gold serjeant's ring. England, c.1525–50. Inscribed *Vivat rex* et *lex* ('Long live the king and the law').

V&A: M.51–1960. Given by Dame Joan Evans

66 Gold serjeant's ring. England, 1576–7. Inscribed *Lex regis praesidium* ('Law is the king's protection'), a motto used at the general call for serjeants-at-law in 1577. At the general call, new serjeants-at-law were appointed and festivities including the presentation of rings were held.

V&A: M.53-1960. Given by Dame Joan Evans

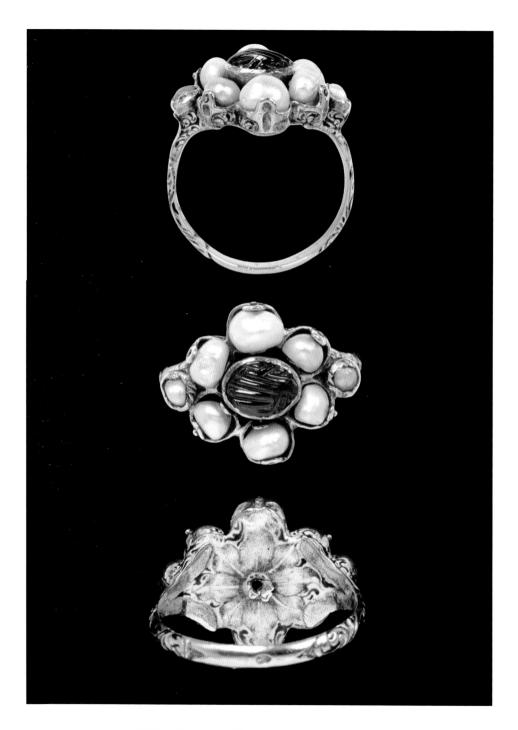

67 Enamelled gold ring (three views) set with pearls and an almandine garnet engraved with clasped hands. Italy, c.1640-60.

V&A: 857-1871

Fashions in 17th-century rings

The fantastical forms of Renaissance rings were gradually simplified as the 17th century progressed. Heavy sculptural shoulders and bezels became plainer frameworks for more abundant gemstones in the new rose-cut style. In 1661 the Parisian jeweller Robert de Berquen lamented that wealthy ladies, jealous of their rivals' sparkling rose cuts, were reducing the value of their diamonds by having them recut.²² Rock crystal, known in England as Bristol or Bristowe stone, was sometimes used as a substitute for diamonds (fig. 69). Fnamel was mostly constrained to the underside of rings, often in naturalistic floral styles (fig. 67). Designs based on the botanical world by French

artists such as François Lefèbre, Étienne Canteron, Gilles Legaré and Jean Toutin were disseminated through design books, creating an international style.

Rings continued to be worn in some number, sometimes tied to the wrist with a black thread, a fashion seen in portraits of the period such as that of Alathea, Countess of Arundel and Surrey (fig. 60). They could also be tied to the cuffs or hung around the neck. Writing to his wife in 1653, Henry Oxinden remarked that, 'My brother had 2 rings more than I saw before uppon each cuffe string, of the value of 501 [I: pounds] the piece, besides other rings upon his fingers.'²³

68 (left) Enamelled gold ring set with green glass. Europe, 1650–1700. V&A: 194-1864

CHAPTER THREE

1700-1820

In the 18th century the currents of artistic development can be traced through iewellery. from the delicate, fantastical creations of Rococo goldsmiths to elegant Neoclassical rings. Rings were also used to affirm political loyalties and commemorate public figures. The diamond ring was not only given at a betrothal or wedding but became an essential accessory for the well-dressed gentleman, its importance illuminated by Marcia Pointon's research.1 Sparkling on a manicured hand, it might dazzle buyers at James Christie's auction house in London, or in 1742 allow a confidence trickster to pass himself off as a baronet by appearing 'in black Velvet, with a good Watch in his Pocket, and a Diamond Ring on his Finger'. The diamond ring appears frequently in portraits of the period, such as that of Johann Christian Bach (1735-82). The elegantly dressed composer holds a sheet of music and wears a ring. probably set with a diamond, on his little finger (fig. 71)." A writer in the Universal Spectator in 1734 argued that a diamond ring was 'the most necessary Qualification, in my Opinion, for a polite Orator'. He lamented that in ancient Greece and Rome Demosthenes, Cicero or Quintilian had not, however, mentioned thisand went on to explain that:

Tho' the thing itself is necessary, yet the Art of using it is much more so, the displaying of a fine Brilliant glittering on the little Finger, when the hand waves gently along with a soft smooth sentence, adds an irresistible Force to whatever you deliver, gives it the Stamp of Sterling Wit, and makes it pass current.

If getting the worse of an argument, he continued:

There is no more necessary, but to make an Extension of that Hand on which you wear your Diamond and you'll infallibly dazzle [your adversary's] Understanding, confute his Syllogism, and confound his Logic.³

Fashions in 18th-century rings

Delicate giardinetti, or 'little garden', rings are some of the prettiest creations of the mid-18th century. Drawing on the fashion for flowers in jewellery, silks and interior design, gemstones and glass were set in a framework of metal to create bunches and vases of flowers. A 1765 advertisement in the New York Mercury appealed for the return of 'one [ring] set in the Form of a Flower-pot, the middle a Diamond, two Sparks, three Rubies above, and an Emerald and a Topaz on each side'.4 A charming love gift from this period was made in the form of a gold ring with an enamelled heart framing a tulip, symbolizing perfect love, inscribed Doux et sincere ('Gentle and sincere'; fig. 73). Rubies and diamonds, signifying passion and eternity, were a popular combination for romantic rings (fig. 76).

The delicate hoops and bezels of these dainty rings presented a challenge to the maker. In 1761 the London jeweller John Leigh explained the difficulties in making

fancy-rings, which require but a very slight shank to go about the finger, and if the ring is not made hard, the workman gets no credit by his work; for was it made of standard gold, it would bend like a bit of lead upon your finger; this is the reason we make them of a lower standard than other gold rings; let any man contradict me who can.⁵

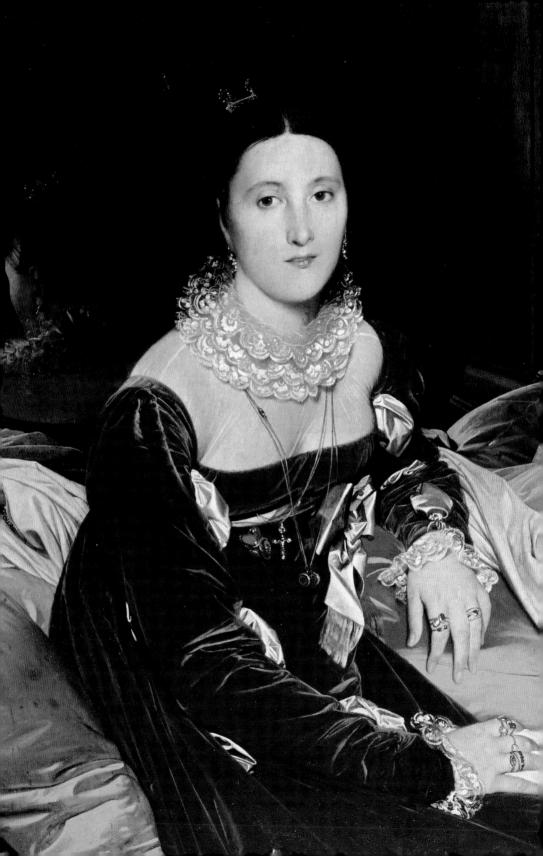

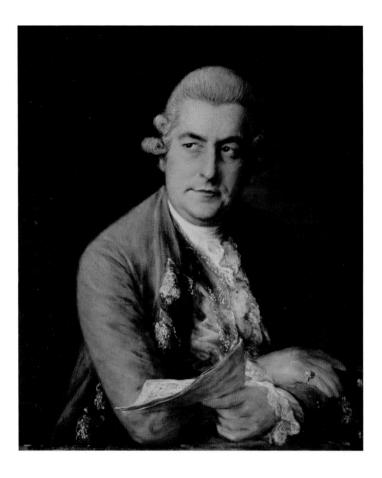

Hearts and clasped hands continued to be used in love rings. Irish 'claddagh' rings, the name taken from a Galway village, feature hands holding a crowned heart (fig. 78). The design was inspired by medieval 'fede' rings (see p. 17) and is still commonly worn in Ireland today. The term 'claddagh' probably originated in the 19th century, along with a rich folklore about its origins. ⁶

Rings in the Rococo style, fashionable from 1730 to 1760, were characterized by swirling, asymmetric curves and naturalistic ornament. By 1770 Neoclassicism, drawing inspiration from the culture of ancient Greece and Rome, had

come into fashion, and rings with symmetrical oval or rectangular bezels, decorated with classical motifs or geometric patterns, were increasingly common. In 1790 a London pawnbroker described his stock as 'two old fashioned rings; the one in the form of two hearts; the other was intermixed with coloured stones, in the form of a basket of flowers'. He deemed both fit only to be broken up for the value of the materials.⁷

Wedding rings

Although wedding rings varied greatly in style over the centuries, their importance was always recognized. Before the mid-18th century the

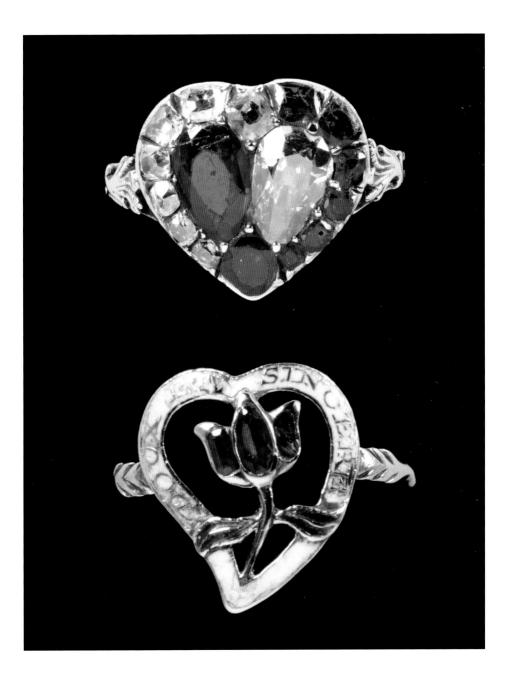

72 Gold and silver ring set with rubies and diamonds. Europe, c.1780. Setting the diamonds in silver enhances the whiteness of the stones; the rubies are set in gold.

V&A: M.171-2007. Given by the American Friends of the V&A through the generosity of Patricia V. Goldstein

73 Enamelled gold ring set with garnets, Possibly England, 1730-60.
Inscribed Doux et sincère ('Gentle and sincere').

V&A: M.170-1962. Given by Dame Joan Evans

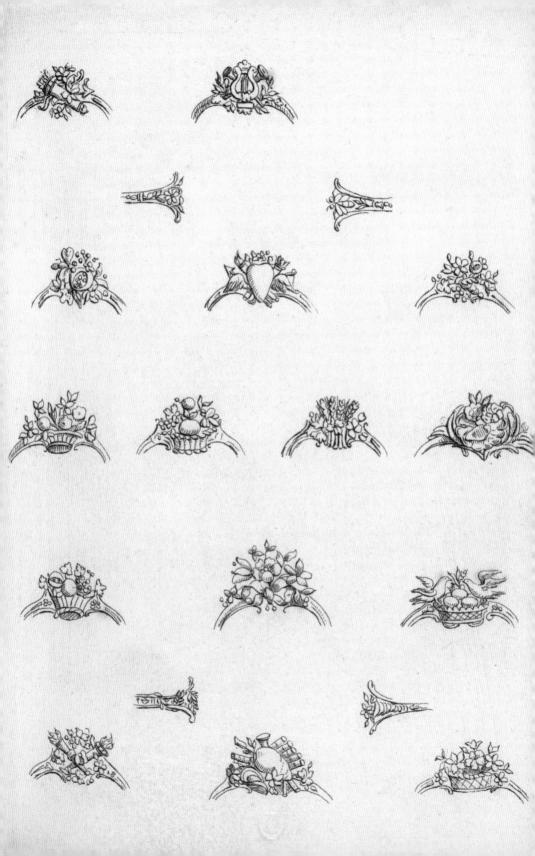

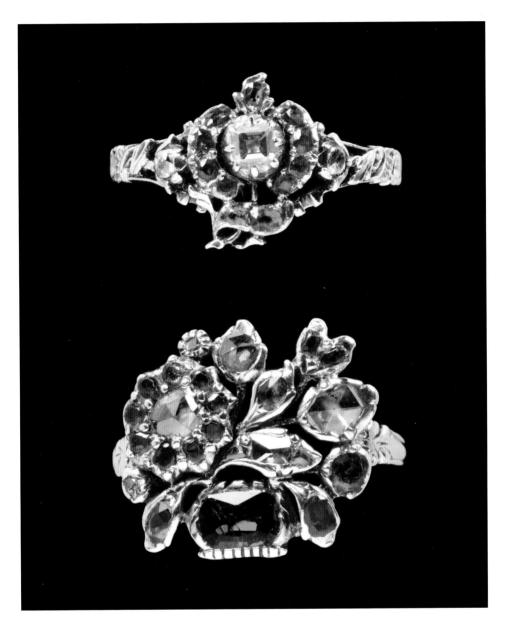

74 (left) Designs for *giardinetti* rings from J.B. Pouget's *Traité des pierres précieuses*. France, 1762. V&A National Art Library, press mark 209.J.1

75 Gold ring set with a table-cut yellow diamond, brilliant-cut white diamonds, rubies and emeralds in the form of a pomegranate. Europe, 1730-60.

V&A: 8548-1863

76 Gold ring set with rose-cut diamonds, rubies and emeralds.
Europe, 1730–60. Small, relatively inexpensive cuts of gemstones combine to form a graceful basket of flowers.

V&A: 970–1871

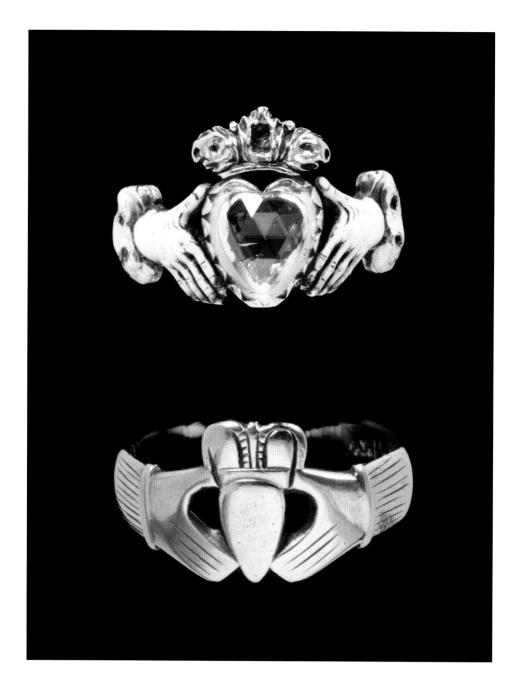

77 Enamelled gold wedding ring set with rose-cut diamonds. England, c.1706. Inside of hoop inscribed 'Dudley & Katherine united 26 Mar. 1706'. V&A: 302-1867

78 Gold 'claddagh' ring. Made by Andrew Robinson, Galway, Ireland, 1750–1800. Inside of hoop inscribed 'JMM'.

V&A: M.12-1961

GRETNA GREEN Striking the From while it is hot .

lawful basis for a marriage was simply the exchange of vows in the present tense by the two parties, and a wedding could take place anywhere at any time of day. When determining the legitimacy of a union, however, the use of a ring became a key question. In 1706, when Robert Fielding was prosecuted for his bigamous marriage to Barbara, Duchess of Cleveland, witnesses testified to having seen the 'Ceremony of the Ring'. The ring was then:

Produc'd by the Proctor of Doctors Commons [the society of lawyers in London practising civil law], with this Device engraven in it tibi Soli, 'for thee alone'. The Goldsmith that made the Ring, deposed he made it by Mr. Fielding's Order, and the Device was Mr. Fielding's.⁸

Scandals such as the kidnapping of heiresses for forced marriages, often taking place in the precincts of London's Fleet Prison, and the difficulty in proving whether a wedding had occurred at all, led to calls for reform. The system was regularized by Lord Hardwicke's Marriage Act of 1753, which stipulated that a wedding could take place only in an Anglican church during the hours of daylight after full

publication of the banns unless a private licence was bought, an expense beyond the means of most. As enforcement of the Marriage Act increased, the emphasis gradually shifted in legal cases from the use of a ring to the evidence of church registers and witnesses.

Gem-set hoops to secure wedding rings in place came into fashion towards the end of the 18th century. In Jane Austen's novel Northanger Abbey (1817), probably written in the late 1790s, Isabella Thorpe daydreamed of her new life as a bride with her own carriage and a 'brilliant exhibition of hoop-rings on her finger'.9 In 1761 Kina George III (1738-1820) gave a diamond hoop ring to Queen Charlotte (1744-1818) that was designed to stand no higher than her wedding ring. Mrs Charlotte Papendiek, Assistant Keeper of the Wardrobe to the Queen, recalled that 'on that finger the Queen never allowed herself to wear any other in addition although fashion at times almost demanded it'.10 George III's daughter Princess Mary (1776-1857) wore a ring set with her father's hair at her own wedding in 1816, having 'a superstitious dread of misfortune' if she omitted it.¹¹ Following an earlier tradition, souvenir rings continued to be given to wedding guests. At the 1791 marriage in Berlin of Frederick Augustus, Duke of York (1763–1827), the second son of George III, to Princess Frederica of Prussia, each guest received a enamelled ring inscribed Soyez heureux ('Be happy').

Memorial and mourning rings

Similarly, the custom of having rings made to remember friends and family endured, and became hugely popular during the 18th and 19th centuries. In 1753 Dame Anna Maria Shaw left her friend Mrs Bridges 'my new ring sett with diamonds which I made in remembrance of my late dear daughter'. Although black is the colour commonly associated with death, white enamel was often used on memorial rings commemorating children, such as on that for the eight-month-old Matthew Arnold (fig. 81), and those who were unmarried. Both black and white enamels were used on a mourning ring that commemorates the tragic death of seven children, possibly from an epidemic of a disease

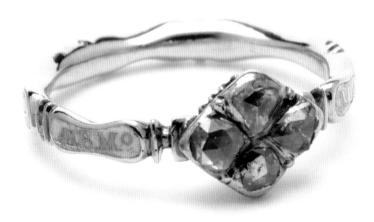

81 Enamelled gold memorial ring set with rose-cut diamonds. England, 1742. Inscribed 'Matthew Arnold died 10 May 1742 aged 8 months'. V&A: M.28-2006. Bequeathed by Shirley Mary Olson

such as smallpox (fig. 83). Another child's memorial ring, for the two-year-old Butterfield Harrison, shows a drooping rosebud and the inscription 'nip't in the bud', symbolizing Butterfield's short life (fig. 86).

Memorial rings served to acknowledge and cement social ties, as witnessed in the will of Dame Cecilia Garrard (d.1753), in which she set out a series of gifts:

To my careful and skilful physician Doctor Tebb and to his lady I leave to each a mourning ring as an acknowledgment for the diligent and obliging care with which he has attended me in several dangerous fits of sickness ... To my late good neighbours Mr Royston and his lady I bequeath to each a mourning ring which I beg them to accept as a token of my thanks and remembrance for their civility ... And to all my kind obliging friends who have been so good to enquire after me in my late sickness, I leave to each a mourning ring as a token of my esteem and acknowledgment of their friendly civility. 13

Mourning rings could become treasured possessions and subsequently be passed on to others. In his will of 1792 George Mason gave 'to Mr John Moncure a mourning ring of three Guineas which I desire him to wear in memory of my esteem for my much lamented friend his deceased father'.14 Dr Samuel Buxton, a minister at Salem. Massachusetts, who died in 1758, left his heirs a quart tankard filled with mourning rings. 15 Anne Houblon, Lady Palmerston, had the mourning rings she inherited made into a pair of gold cups, bequeathed to her husband in 1735 as 'the 2 lesser Chocolate Cups you would sometimes look on as a Remembraunce of Death, and also of the fondest and Faithfullest Friend you ever had'. 16 The will of George Washington (1732-99), first President of the United States, stated that his bequest of rings to his sister-in-law was not made 'for the intrinsic value but as mementoes of my esteem and regard'.¹⁷

The inclusion of hair from the deceased in mourning rings gave them a very personal

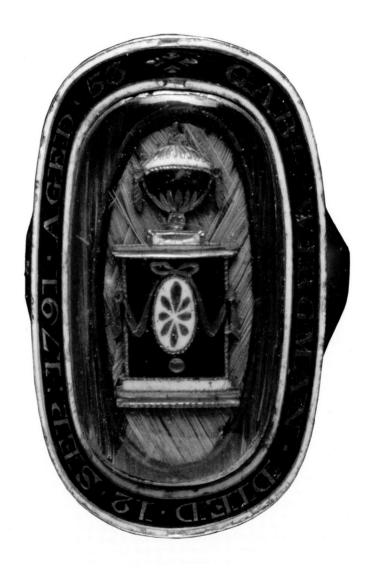

84 Enamelled gold memorial ring set with woven hair under a rock-crystal panel.
England, 1791. Inscribed 'GabL Wirgman/ Died 12 Sep 1791/Aged 53'. This ring was presented to Mr J. Garle, son of Wirgman's old friend, as a 'particular token of remembrance'.

V&A: 907-1888

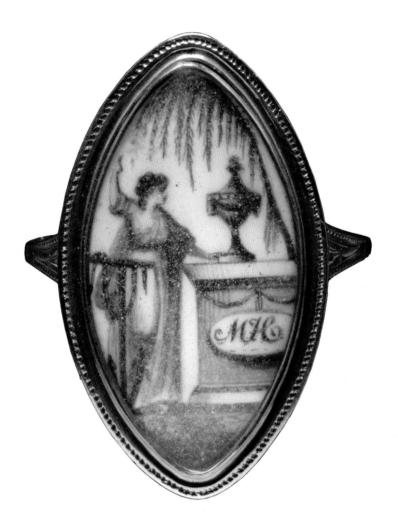

85 Gold memorial ring set with a painted sepia miniature under crystal. England, 1785. Inscribed 'Martha Holworthy ob.13 Sep 1784 aet 64'. Family records show that Martha Bolton gave birth to six children before finally marrying Daniel Holworthy in 1757. His death in 1763 led to a protracted legal quarrel with the legitimate children from his first marriage. ¹⁸ V&A: 915-1888

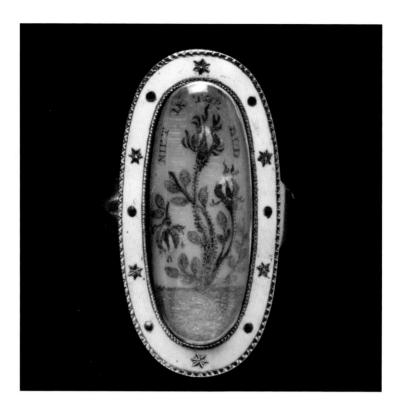

appeal. The London jeweller Gabriel Wirgman, who died in 1791 aged 53, left instructions in his will to have a ring made 'in the most fashionable manner with some of my hair and some of Mr Garle's father's hair' (fig. 84). Mr Garle was a family friend and benefactor who had died some years earlier. Yeat and plain rings' were to be presented to Wirgman's brothers and sisters.

Jewellers advertised their ability to make mourning rings neatly and expeditiously. Working in the Rococo style from about 1730 to 1760, they set a small gemstone or crystal in a hoop divided into scrolls, and enamelled with the name and dates of the deceased (fig. 81). The London jeweller John Leigh described the work involved in making mourning rings when

defending himself against an accusation of coin clipping in 1761. He claimed that gold filings found in his possession came not from gold coins from which the edges had been dishonestly clipped, but from mourning rings made to the official 22-carat standard:

These were filings of mourning-rings, with a great deal of scroll-work, which all jewellers know there is a great deal of filing in making one of them.²⁰

The large marquise and navette bezels fashionable from 1770 offered a canvas for funeral urns, broken columns, trailing fronds, extinguished torches and grieving women bent over monuments, a visual language taken from Neoclassicism.

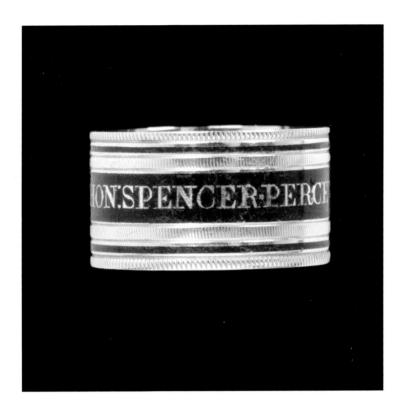

Rings commemorating public figures and events

Public figures as well as private individuals were remembered in rings. An enamelled gold memorial ring commemorates the assassination of the British Prime Minister Spencer Perceval (1762–1812) in the lobby of the House of Commons. His death left his wife alone, pregnant with their 20th child. It is inscribed 'Rt. Hon. Spencer Perceval died 11 May 1812 aged 49' and 'Died by the hand of an Assassin' (fig. 87).

The heroic death of Admiral Horatio Nelson (1758–1805) at the Battle of Trafalgar created a great demand for memorabilia, including quantities of rings. On his deathbed Nelson left his hair to his lover, Emma Hamilton, most likely

so that she would have it incorporated into jewellery. Dr William Nelson, the admiral's brother, ordered mourning rings from the London jeweller John Salter for family and friends, and every admiral and post-captain who fought at Trafalgar. The death of James Newman-Newman (1767–1811), Captain of HMS Hero, was similarly memorialized on an enamelled gold ring (fig. 94). His ship sank in the hurricane of Christmas Eve 1811 off the coast of Jutland, with the loss of 600 lives.

The Prince Regent (later King George IV; 1762–1830), brother of Princess Amelia (1783–1810), commissioned a group of 52 rings to commemorate his sister's untimely death (fig. 88). The youngest child of George III and Queen Charlotte, Amelia died at the

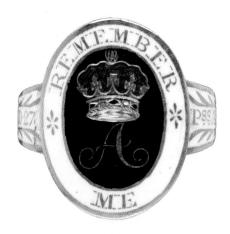

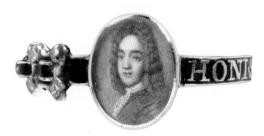

- 88 Enamelled gold memorial ring for Princess Amelia. Made by royal jewellers Rundell, Bridge and Rundell, London, England, 1810. Inscribed with the initial 'A' and 'Remember me'. V&A: M.151-1962. Given by Dame Joan Evans
- 89 Enamelled and gold garter ring set with diamonds and a portrait miniature under rock crystal. England, c.1730-70. Inscribed with the motto of the Knights of the Order of the Garter: Honi soit qui mal y pense ('Shame on him who evil thinks').
 V&A: M.19-2004. Given by Edward Donohoe
 - 90 Gold freemason's ring set with emeralds and rose-cut diamonds.

 Possibly Poland or Germany, 1750–75.

 V&A: 212-1870

age of 27 after a long illness. Her death caused great pain to her parents: the Princess's nurse reported that 'the scenes of distress and crying every day ... were melancholy beyond description'. Her father, the King, was plunged back into madness.

Wearing a ring could advertise political loyalties or membership of a club or social group; a ring could also act as a symbol of office. A late 18th-century freemason's ring, probably a private commission for a wealthy man, is decorated with the Masonic emblems of a set square, a ruler and compasses (fig. 90). A small number of rings in the form of a garter and with the motto of the Order of the Garter,

England's oldest chivalric order, have been found (fig. 89). They were perhaps worn by members of the Order or left as bequests.

Although wearing fine jewellery became unacceptable during the French Revolution of 1789, plain rings commemorating Revolutionary heroes were permitted. A silver ring from the 1790s (fig. 97) bears the portraits of two heroes of the French Revolution: Jean-Paul Marat, murdered in his bath on 13 July 1791 by Charlotte Corday; and Louis-Michel Lepeletier de St Fargeau, killed on 20 January 1793 by a Royalist incensed that Lepeletier de St Fargeau had voted to execute King Louis XVI (1754–93).

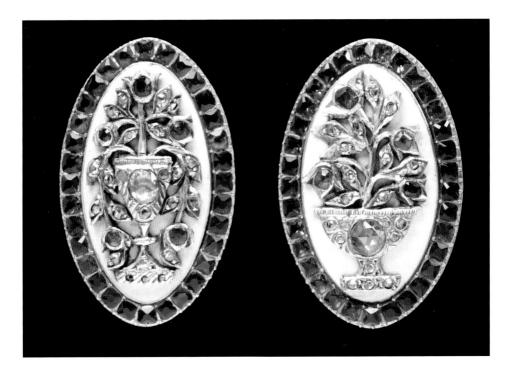

91 (left) One of a pair of enamelled gold mourning rings set with rose-cut diamonds, rubies, emeralds and amethysts. England, c.1787. Inscribed 'Cease thy tears, religion points on high/CS ob.25 Jan 1787 aet 70'.

V&A: M.163-1962. Given by Dame Joan Evans

92 (right) One of a pair of mourning rings. England, 1792. Made five years after its counterpart, possibly to commemorate a spouse or sibling.

Inscribed 'IS ob.18 Sep 1792 aet 72'.

V&A: M.164-1962. Given by Dame Joan Evans

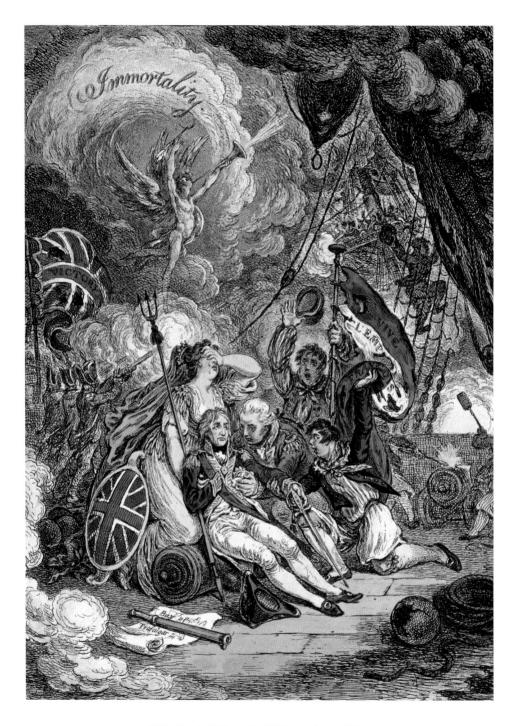

93 The Death of Admiral, Lord Nelson by James Gillray, published December 1805. Courtesy of the Warden and Scholars of New College, Oxford/Bridgeman Images

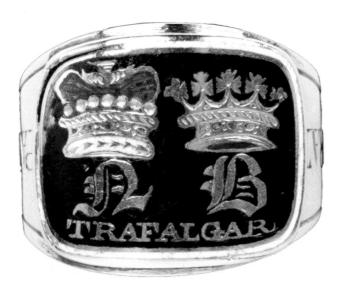

94 Enamelled gold memorial ring for Captain Newman-Newman. England, c.1811. Inscribed 'Captain James Newman-Newman lost off the Haak in the Hero 74, December 24, 1811, aged 46'. V&A: M.314-1926

95 Enamelled gold memorial ring for Admiral Horatio Nelson. Possibly made by John Salter, England, c.1805. Inscribed 'Trafalgar. Lost to his country 21 October 1805, aged 47' and Nelson's motto *Palman qui meruit feram* ('Let him who earned it bear the palm [of victory]').

V&A: M.234–1975. Given by Dame Joan Evans

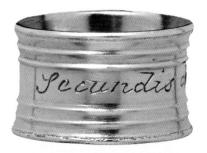

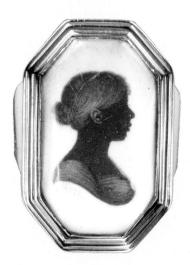

96 Gold serjeant's ring. Made by Edmund Prince, England, 1770. Inscribed Secundis dubiisq. rectus, taken from the words of the Roman poet Horace which translate as: 'You possess a mind both sagacious in the management of affairs and steady at once in prosperous times.' This ring was given at the general call for the serjeants-at-law of Sir William Blackstone.

V&A: M.58–1960. Given by Dame Joan Evans

97 Stamped silver ring. France, c.1793. Such rings were popular souvenirs of the French Revolution in 1789.

V&A: 931–1871

98 Gold ring set with a watercolour silhouette painted on ivory by John Miers.
England, c.1810.

V&A: M.92–2007. Given by the American Friends of the V&A through the generosity of Patricia V. Goldstein

New materials and techniques

In 1763 the gem engraver and modeller James Tassie (1735–99) of Glasgow and the scientist Dr Henry Quin developed a hard glassy paste that was particularly suited to reproducing fine details. Tassie and his nephew William then mass-produced moulded glass portraits and imitations of ancient gems to be set in rings. The ceramics firm of Wedgwood also copied classical designs, using its trademark jasperware (a type of fine unglazed porcelain) to create small plaques to be set in jewellery (fig. 99).

During this period silhouettes or 'profiles' were set in rings to be given to friends and lovers.

They were a great commercial success as an alternative to painted miniatures because they could be reproduced quickly and cheaply. John Miers (c.1758-1821) of the Strand in London, who was one of the principal exponents of the art (fig. 98), advertised himself as 'Miers (Late of Leeds) Executes profiles on Ivory to set in Rings, Lockets. Bracelets ... He keeps all the original shades & can supply those he has once taken with anv number of copies'.²² Johann Kaspar Lavater's popular Essays on Physiognomy, published in 1775, increased the appeal of these profiles by promoting the view that a person's character could be analysed through his or her facial features. 23

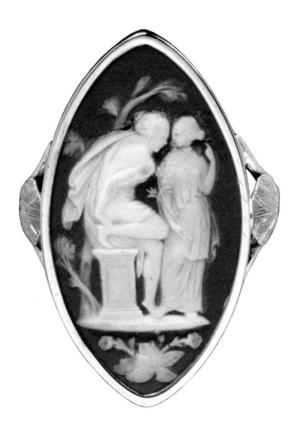

99 Gold ring set with a Wedgwood jasper plaque, adapted from a larger scene showing a sacrifice. England, c.1780.

V&A: 621–1894

CHAPTER FOUR

1820-1900

The Romantic Movement, expressed through literature and art, as well as jewellery, rediscovered the styles of the Middle Ages and the Renaissance. Across Europe designers looked back to what were perceived as eras of superior national achievement, lost golden ages not only in politics but also in art and design. Goldsmiths drew inspiration from medieval and Renaissance models, and, in the making of jewellery, the skills of the modeller and chaser were celebrated as they had not been since the early 17th century. Benvenuto Cellini's autobiography, published in French in 1822, gave fresh ideas to 19th-century jewellers. Cellini had been the most famous Italian goldsmith of the Renaissance; in tribute, the French historicist jeweller François-Désiré Froment-Meurice (1801-55) came to be addressed as 'cher Benvenuto'.1

Contemporary excavations of ancient sites in Italy offered alternative inspiration for jewellers. The firm of Castellani in Rome was the pre-eminent exponent of neo-Etruscan gold jewellery. Styles of the 18th century, including Rococo and Neoclassicism, were also revived, ensuring customers had no shortage of choice. From the late 18th century to the 1840s jewellery set with micro-mosaic panels, composed of minute glass tesserae (tiles), became a popular souvenir for visitors to Rome. The popularity of micro-mosaics then faded, until Castellani revived them in the 1870s (figs 106 and 107). As Alessandro Castellani later recalled:

When we took up the subject the greater number of those who followed the occupation of working in mosaic at Rome were almost unemployed ... We therefore applied mosaics to classical jewellery, imitating at first the antique scenic masks, and many Greek and Latin inscriptions, and our designs were very soon copied elsewhere.²

Commercial jewellery catalogues show the range of rings that were available throughout the 19th century. A page of rings from a cataloque by the French firm Lefebvre illustrates a number of fashionable shapes, some set with turquoises, including serpents, flowers and rings in the 18th-century style (fig. 112). New styles emerged, including the 'cross-over', in which the hoop was split to make two ends, or was formed from two overlapping bands so that stones were set diagonally across the ring. Clusters of stones looked particularly dramatic and customers often preferred to make an impression through the glamour of the stones rather than any originality in design. An Illustrated London News columnist in 1887 regretted the sight of 'fine stones set in straight rows with as much notion of beauty and originality in their arrangement as in an old-fashioned box edging to a garden'.3

Rings continued to be lovers' gifts. Motifs included flowers, hearts, acrostics using stones to spell out messages such as 'dearest', and rebuses, in which pictures created romantic phrases. Snakes symbolized eternity, and were used on both love and mourning jewellery. An emerald-set ring in the form of a serpent was given to Queen Victoria (1819–1901) by Albert for their engagement in 1839. Wedding rings were accorded huge symbolic value, described sentimentally by the antiquary Thomas Crofton Croker in 1853 as 'a gift far more precious than the most costly tiara of diamonds could possibly be'. An Act of Parliament in 1855 required that all wedding rings bear hallmarks.

101 Chiselled iron ring with cast-gold figures of a muse with putti, possibly from models by J.B. Klagmann.
Paris, France, c.1854. Made by François-Désiré Froment-Meurice, who died shortly before the opening of the 1855
Paris Exposition Universelle (International Exhibition), at which the V&A bought this ring for £10.
V&A: 2658-1856

102 Enamelled gold ring set with brilliant-cut diamonds and a plaque by Charles Lepec featuring the goddess Psyche. Paris, France, c.1870. Bought by Harriet Bolckow, the wife of a Middlesbrough steel magnate, from the jeweller Robert Phillips. Lepec was awarded a gold medal for enamelling at the 1867 Paris Exposition Universelle.

V&A: 746-1890

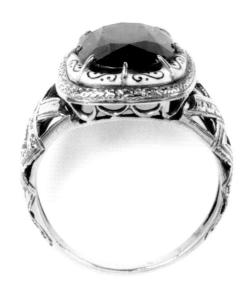

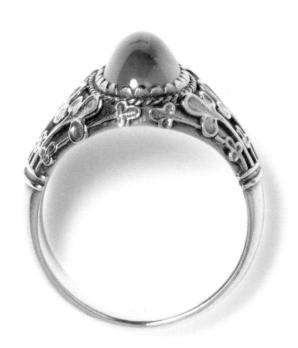

103 Enamelled gold ring set with a sapphire. Designed and made by Carlo Giuliano, London, England, c.1875. V&A: M.327-1922

104 Gold ring set with a cabochon sapphire. Designed by William Burges, England, c.1870. V&A: M.281-1975. Given by Dame Joan Evans

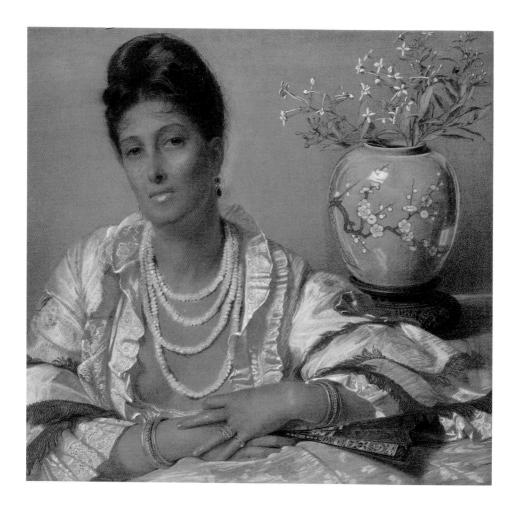

105 Mrs Charles Augustus Howell (detail) by Frederick Sandys. England, 1873.

Mrs Howell wears a number of rings, some set with turquoise and one possibly in the shape of a serpent.

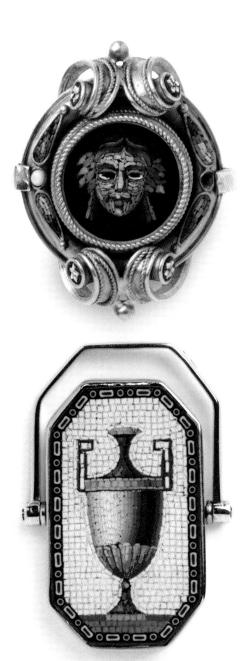

106 Gold ring in the Renaissance style, set with a mosaic of a classical mask. Rome, Italy, c.1870.
V&A: Loan:Gilbert.129-2008

107 Gold ring in the Neoclassical style, set with a mosaic of a classical vase.

Rome, Italy, c.1800. The angular hoop echoes the shape of the octagonal bezel.

V&A: Loan:Gilbert.164-2008

108 Gold wedding ring threaded onto a gold chain. London, England, 1858-9.
It belonged to Jane Morris (née Burden), who married William Morris, artist, designer, author and visionary socialist, on 26 April 1859.
Bequeathed by May Morris. V&A: M.37&A-1939

109 Gold serpent ring set with rubies, possibly once owned by George IV.

England, 1800–30.

V&A: 476–1903

110 Gold, glass and enamel ring. France, 1819–38. The combination of the pansies and inscription can be read as Pensez a votre ami ('Think of your friend'). Given by Geoffrey and Caroline Munn. V&A: M.227–2007

111 Gold ring set with diamonds. England, c.1890. Inscribed with the goldsmith's mark 'WGM'. The stones are sunk into the surface of the bezel in a Gypsy setting, a style that was introduced in the last quarter of the 19th century.
Bequeathed by Rosemary Eve Lawrence. V&A: M.23-1996

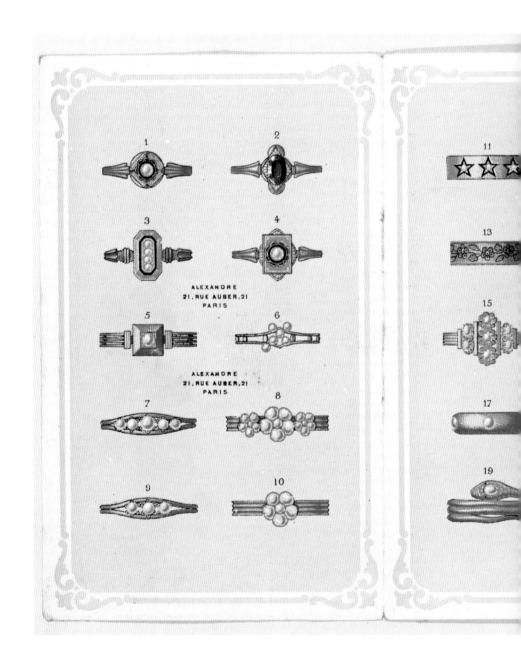

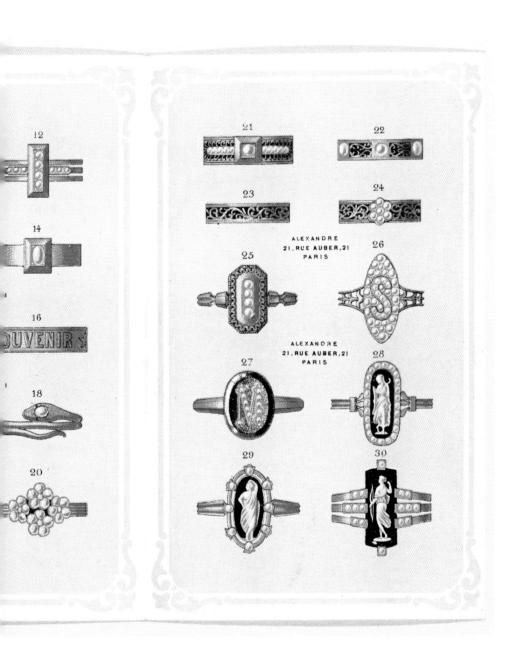

112 Designs for rings from *Album of Designs* by H. Lefebvre.
Paris, France, 1866.

V&A National Art Library, Manuscript MSL/2010/1

113 Gold ring set with a turquoise scarab and brilliant-cut diamonds. Europe or USA, 1850–1900. Archaeological excavations in the 1850s sparked a fashion for jewellery inspired by the art and mythology of ancient Egypt.
Given by the American Friends of the V&A through the generosity of Patricia V. Goldstein. V&A: M.155–2007

114 Enamelled gold ring. France, 1830–60. Small hinged lids enamelled with daisies and roses open to reveal inscriptions: Je t'aime / un peu / beaucoup / passionnément / pas du tout ('I love you/a little/a lot/passionately/not at all'), a romantic rhyme used when plucking the petals from a daisy.

V&A: M.172–1962. Given by Dame Joan Evans

Gentlemen's signet rings experienced a revival in the second half of the 19th century, with the crest or initials preferably carved into a hardstone rather than a precious stone. One example is engraved with the arms of William Thomson, Archbishop of York from 1863 to 1890. with crozier, mitre and cross (fig. 115). Thomson had been a reforming head of Queen's College. University of Oxford, and this ring was presented to him by his Oxford friends. Excessive jewellery on men was, however, satirized: in William Makepeace Thackeray's novel Pendennis (1848), Major Pendennis deplored a young acquaintance: 'Did you remark the quantity of rings and jewellery he wore? That person has Scamp written on his countenance if any person had.'5 Women, on the other hand, could wear a profusion of rings across their fingers, a fashion noted by a London servant remarking on how the elderly ladies he waited on 'dressed up monstrous fine with their iewellery'.6

Rings remained part of the formal apparatus of mourning. Hair continued to be often used in designs, either incorporated in the image or dissolved into the pigment, and books of designs and instructions were available to jewellers and amateurs. A Jeweller's Book of Patterns in Hair Work by William Halford and Charles Young, published in about 1863, offered a great variety of designs suitable for hair jewellery; while in 1852 the Hairworker's Manual by William Martin addressed the fears of those who had sent treasured hair to be made into iewellery and on its return detected 'shades of other hues'. A ring in the form of an enamelled gold snake, made for the widow of George. seventh Earl of Waldegrave, incorporated a locket containing his hair (fig. 117). George died at the age of 30, after a disgraceful career in which he was imprisoned for drunken assault and subsequently sold the contents of the renowned Gothic Revival house at Strawberry

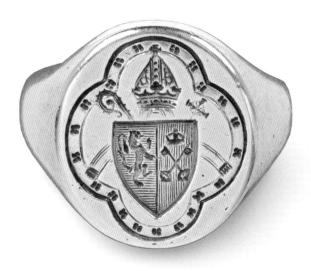

115 Gold ring once owned by Archbishop William Thomson. Made by Charles and William Scott, England, 1862. Engraved with Thomson's coat of arms. Given by Lady Thomson. V&A: M.111-1945

116 Enamelled gold ring. London, England, 1860-1. Bezel inscribed 'AEI' ('Always') in diamond sparks (small, low-value diamonds); inside of hoop inscribed 'Hannah Darby died 20th Decr 1860. Aged 77'.

V&A: M.20-1970

117 Enamelled gold mourning ring in the form of a snake, set with diamond sparks for eyes. England, 1846. Inside of hoop inscribed 'George Edward, Earl of Waldegrave, obt.28 Sepr. 1846, aet 30'. A compartment concealed at the back of the bezel contains plaited hair.

V&A: M.169–1962. Given by Dame Joan Evans

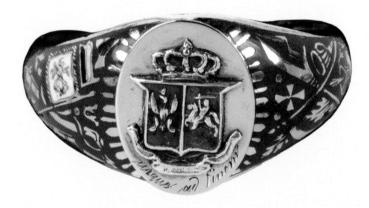

118 Bronzed copper patriotic ring. Made by Froment-Meurice, France, c.1871. V&A: M.35-1982. Given by Mrs K. Greenwood-Wynne

119 Enamelled gold and silver patriotic ring. Europe, c.1863.
Engraved with the arms of Poland and Lithuania, and inscribed

Usque ad finem ('To the very end').

V&A: 1831–1869

Hill, Twickenham, which had been assembled by his distant relative, the politician and antiquarian Horace Walpole. Despite her husband's behaviour, his remarkable widow, Frances, became a prominent political hostess and restored the house.

Memorial rings gave great comfort to mourners, as Emily Palmer's description of the rings made after the death of her sister Dorothea in 1852 touchingly illustrates:

Dear Laura [her sister-in-law] has given us each a ring of our Do's hair with a small pearl in the middle. I am so fond of it. We chose a ring – and I am glad for 3 reasons. First because always wearing it – helps me always to think of her. – 2nd because a ring seems to be a bond of love – 3rd it being round – a circle reminds one of how one's love and communion with her may and will last for ever if we don't lose it by our own fault. Then the Pearl 'Purity' pleases me so much.⁷

Wearing a ring could advertise a person's political sympathies or show support for a cause, as in the case of earlier jewellery indicating loyalty to the deposed Stuart monarch James II (see p. 55). The French firm Froment-Meurice made rings commemorating the Prussian siege of Paris during the Franco-Prussian War, such as one inscribed in French 'United in danger, united in honour 1870-1871' and the initials 'AM' (Ave Maria; fig. 118). They were described by The Queen magazine as 'some rings ... which the fair Parisiennes are purchasing to present to their husbands as a souvenir of the siege and foreigners are buying as a souvenir of Paris'.8 The wearing of rings that called for the independence of Poland-Lithuania was proscribed in 1867 under threat of severe punishment (fig. 119). Poland-Lithuania had been partitioned between Russia, Prussia and the Hapsburg monarchy and, after the third partition in 1795, ceased to be an independent state. Bitter struggles for sovereignty ensued, with an unsuccessful uprising against Russian rule in 1863.

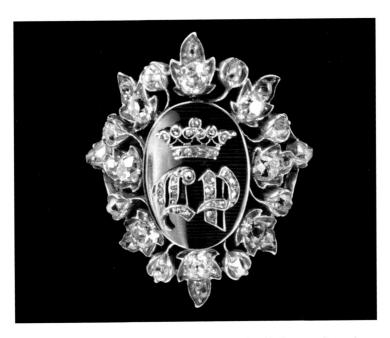

120 Enamelled gold presentation ring set with a border of brilliant-cut diamonds and the cipher of Louis-Philippe, King of the French (1773–1850). Made for the sovereign to present to an appropriate courtier. France, c.1840.

V&A: M.154–1962

CHAPTER FIVE

1900-1950

The 20th century brought unprecedented innovation and diversity in jewellery design as developments in the fine arts were reflected in the creations of jewellers and ring-makers. The Arts and Crafts movement, begun in Britain in the last decades of the 19th century, took inspiration from the writings of the critic John Ruskin (1819–1900) and the designer William Morris (1835–96). Such artists rejected industrial manufacturing and what they regarded as its adverse effects on urban life, and looked to the Middle Ages, aspiring to follow the working practices and design principles of medieval quilds.

Arts and Crafts and Art Nouveau rings

Arts and Crafts designers applied principles of 'honest' craftsmanship and 'truth to materials' to the jewellery they made. Rings made in this style show a preference for the irreqularity of hand-wrought metals and the rounded shapes of cabochon gemstones. One of the most accomplished and innovative jewellery designers of this period was Henry Wilson (1864-1934). The 'Cathedral' ring made by Wilson, inspired by Gothic architecture. was designed by the architect W.R. Lethaby (1857-1931) as a wedding gift for Lethaby's wife, Edith (figs 122 and 123). Henry George Murphy (1884-1939), who had been apprenticed to Henry Wilson in 1899, became one of the finest British exponents of Arts and Crafts and later Art Deco metalwork and jewellery (see pp. 106-9). Their contemporary Reginald Pearson (1887-1915) was described in his obituary as a versatile artist, jeweller and engraver, whose 'hand was ever in

sympathy with the material in which he worked' (fig. 127).1

The Arts and Crafts movement was welcoming to women, many of whom studied in art colleges and studios. Amateur jewellers worked alongside professionals. Ethel Williamson Wyatt (b.1894) studied at the Manchester School of Art, where she made a ring for her mother, Sophia (fig. 125). She went on to work in Egypt as a teacher and in 1927 married Pat Clayton. an explorer and surveyor on whom Michael Ondaatje based the character of Peter Madox in his novel The English Patient. Although the Arts and Crafts movement reached its heyday in the early 20th century, some jewellers continued to work in that style up to the 1930s. They included the London designer Sibyl Dunlop (1889-1968), who had her own shop on Kensington Church Street from the 1920s, and her collaborator and supplier, the Birmingham jeweller Bernard Instone (1891-1987; fias 129 and 130). These jewellers continued to use combinations of brightly coloured gemstones, often still in soft, natural shapes, which contrast with the geometry of later Art Deco jewellery (fig. 126).

The jewellers of French Art Nouveau shared the determination of the Arts and Crafts movement to create jewellery that prized artistry and design above the weight of gems and precious materials. René Lalique (1860–1945) was the pre-eminent exponent of the style in Europe. An Art Nouveau ring by A.C.C. Jahn (1865–1947), Principal of the Municipal School of Art, Wolverhampton, shows the curved lines of a mermaid gazing into her opal mirror (fig. 128).

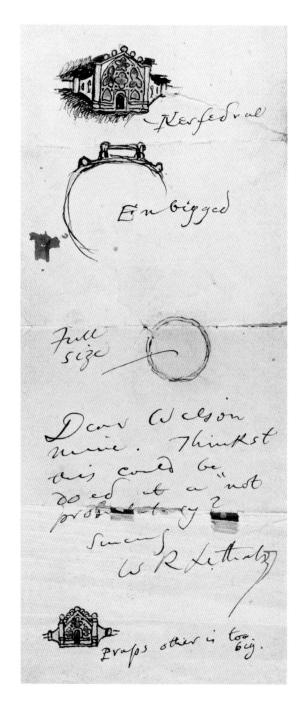

122 Design for 'Cathedral' ring by W.R. Lethaby. England, 1897-1901. Lethaby annotated the design 'Dear Wilson mine' and suggested possible changes to the ring.

V&A: E.665:147-8-1955. Given by Miss Orrea Pernel

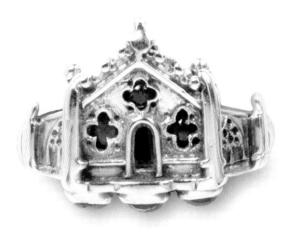

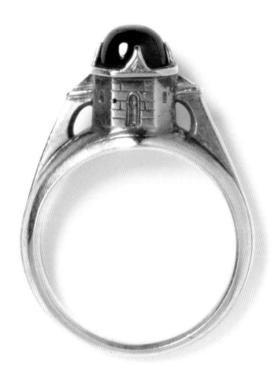

123 'Cathedral' ring, gold set with amethysts, an emerald, a sapphire and a ruby. Designed by W.R. Lethaby. Made by Henry Wilson, London, England, 1901.

V&A: M.6-1934. Given by M. Crosby

124 Gold ring set with a garnet. Possibly made by Carlo Giuliano, England, 1899–1903. Designed by Charles Ricketts for May Morris, the daughter of William Morris, and a talented needlewoman and jeweller.

V&A: M.35-1939. Bequeathed by May Morris

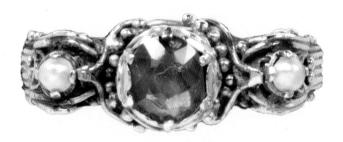

125 Gold ring set with a sapphire and pearls. Designed and made by Ethel Williamson Wyatt as a gift for her mother. England, 1919. Given by A.L. Wyatt. V&A: M.23-1974

126 Gold ring set with sapphires, garnets, amethysts, citrines and green tourmalines. Boston, USA, c.1930.
V&A: M.114-2007. Given by the American Friends of the V&A through the generosity of Patricia V. Goldstein

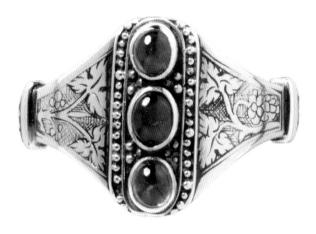

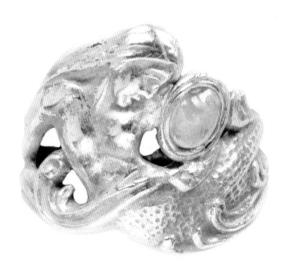

127 Gold niello ring set with sapphires. Made by Reginald Pearson, England, c.1912. Arthur Morley Jones commissioned Pearson to produce this engagement ring for his fiancée, Mary Houseman.² Given by Katherine Chapman. V&A: M.31-1995

128 Gold ring set with an opal. Designed and made by A.C.C. Jahn, England, c.1901.

Jahn Bequest. V&A: M.79-1947

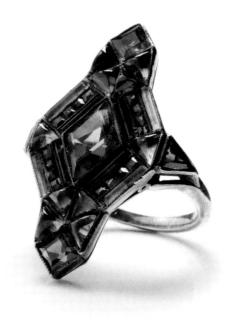

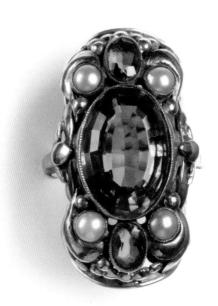

129 Silver ring, set with an amethyst, rubies, sapphires, and green and yellow chalcedony. Designed and made by Sibyl Dunlop, England, c.1930.

V&A: M.14-2013. Given by Gulderen Tekvar

130 Gold and silver ring set with citrines and pearls. Designed and made by Bernard Instone, Birmingham, England, c.1925–35.

V&A: M.216-2011. Given by Gulderen Tekvar. Photograph reproduced with kind permission of Bernard Instone's family.

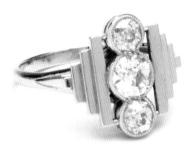

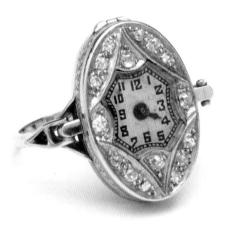

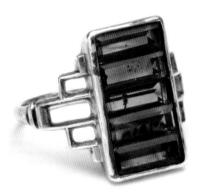

131 Platinum ring set with brilliant-cut diamonds. Designed and made by Henry George Murphy, London, England, 1932. V&A: M.229-1977

132 Watch ring set with platinum and rose- and brilliant-cut diamonds. Made by Nathan Fishberg, London, England, c.1925. Given by Harry Fishberg. V&A: M.241-1977

133 Silver ring set with amethysts. Designed and made by Fred Partridge for his daughter Joan. England, c.1928. Partridge lived and worked for a time in the Arts and Crafts artistic community in Chipping Campden, Gloucestershire, and then in the Sussex village of Ditchling.

Given by Joan Partridge. V&A: M.15-1976

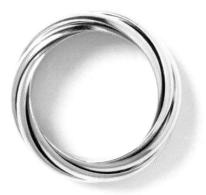

Art Deco rings

The beginnings of Art Deco can be found in the early years of the 20th century, but the movement came into flower at the Paris 1925 Exposition Internationale des Arts Décoratifs et Industriels Modernes (International Exhibition of Modern Decorative and Industrial Arts), from which the name Art Deco derives. Paris set the style for dress and jewellery in the 1920s, creating fashions copied across the world. An appetite for simplicity and symmetry was born, and some jewellers lamented what they saw as the decline of their art. In 1925 the Jeweller and Metalworker magazine regretted that:

The art of ring making as I knew it in days gone by seems to have disappeared. There is no elaborate carving on the shoulders now; no heavy shanks and bold settings. All that appears to be wanted is the stone, and for the purpose of setting, the least gold that can be used. This desire on the part of the wearers is a characteristic of an age which favours a plainer type of work.³

Fashionable Parisian jewellery firms such as Cartier, Mauboussin and Van Cleef & Arpels were at the forefront of the new style. Rings set with large gemstones or the dense concentration of gemstones permitted by lightweight platinum settings created bold and impressive jewels. Writing in the *Goldsmiths Journal* in 1928, a contemporary noted: 'The most striking feature of the new jewellery is the large size of the stones, particularly in bracelets and rings ... In rings, large square-cut stones are the favourites, in most cases reaching all the way to the knuckle.'

The arts of Egypt, China and India strongly influenced Art Deco jewellers, who brought together exotic combinations of colour, such as the deep-hued coral, diamonds and black plastic of a ring by Alexandre Marchak (1892–1975; fig. 137). Arresting colour combinations were also inspired by the stage costumes that Leon Bakst created for Sergei Diaghilev's Ballets Russes, which performed in Paris from 1909; the conjunction of emeralds and sapphires became a trademark of Cartier

By 1929 diamonds and platinum were combined in predominantly 'white' jewellery, which employed virtuoso stone cuts to great effect. Platinum became the first choice for wedding rings, which were often worn with a platinum and diamond solitaire engagement ring. Cartier's 'Trinity' ring, first made in 1924, with three interlocking bands of coloured gold, was an alternative romantic gift (fig. 134).

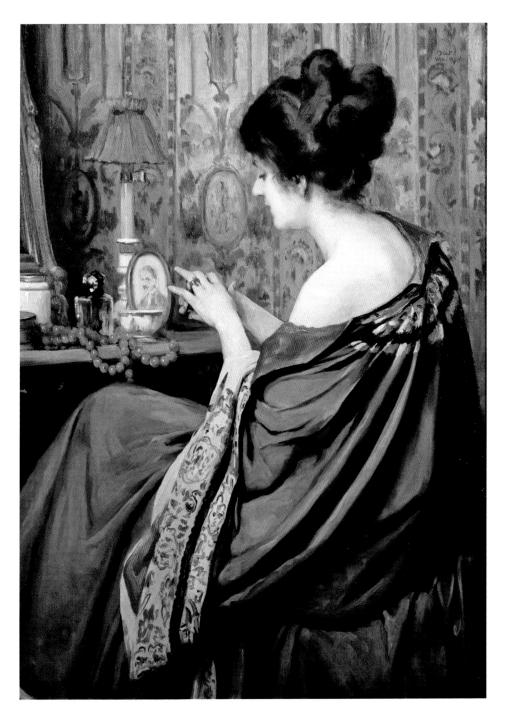

135 *In the Boudoir* by Dolf van Roy. Probably Belgium, c.1916. A young woman, dressed in flowing clothes, gazes at a ring on her fourth finger, perhaps a love gift or engagement ring.

Private Collection/John Noott Galleries, Worcestershire/Bridgeman Images

136 Platinum and gold ring set with amber, jadeite and stained chalcedony. Designed and made by Georges Fouquet, Paris, France, c.1930–5. Its geometric design and choice of colours typify Art Deco principles.
V&A: M.4–1980. © ADAGP, Paris and DACS, London 2011

137 Platinum ring set with coral, diamonds and black plastic.

Designed and made by Alexandre Marchak, Paris, France, c.1920–30.

V&A: M.190-2007. Given by the American Friends of the V&A
through the generosity of Patricia V. Goldstein. © Marchak, Paris

Some Art Deco jewellers took inspiration from abstract art and the Modernist principles of the Bauhaus school of art and design in Germany, rejecting surface ornament and exploring new materials. Designs exploited the aesthetics of the machine age and technological innovations such as the car. A group of avant-garde jewellers in Paris, including Georges Fouquet (1862-1957) and Jean Després (1889-1980), took innovation to the extreme (figs 136 and 138). Writing to an artist friend, Després explained: 'I shall focus primarily on rings. Rings are still what people like most and they're something I manage quite differently.'5 Rings were made from base metals, less expensive gemstones and plastics.

After the white jewellery of the late 1920s, the second half of the 1930s saw a return to gold, when platinum started to be requisitioned for military purposes ahead of World War II. Bezels became more rounded, echoing the flowing lines of women's dresses. Baguette- and roundcut diamonds on a ring from the 1920s create a satisfying geometric design (fig. 143). However, not all customers adopted the new

styles. When the Prince of Wales visited Birmingham's jewellery quarter in 1931, he noted that half-hoop and cluster rings retained their popularity.⁶

The darkening political landscape and difficult economic situation of the 1930s and '40s prompted jewellers to make rings set with large, less expensive gemstones such as rock crystal, quartz and aquamarine. The designer André Arbus (1903-69) expressed the mood at the 1937 International Exhibition in Paris, stating that the aim was 'to create an atmosphere of luxury with inexpensive materials that everyone can afford, taking the resources of our time into consideration'.7 The couturier Coco Chanel (1883-1971) echoed this sentiment, declaring that, 'It is disgusting to wander round loaded with millions because one is rich: jewellery isn't meant to make you look rich, it is meant to adorn you and that is not the same thing at all.'8 For wealthy customers, however, large gemstones were still in voque. Hollywood stars such as Ginger Rogers (1911–95) promoted the fashion by wearing eye-catching 'rocks' (fig. 139).

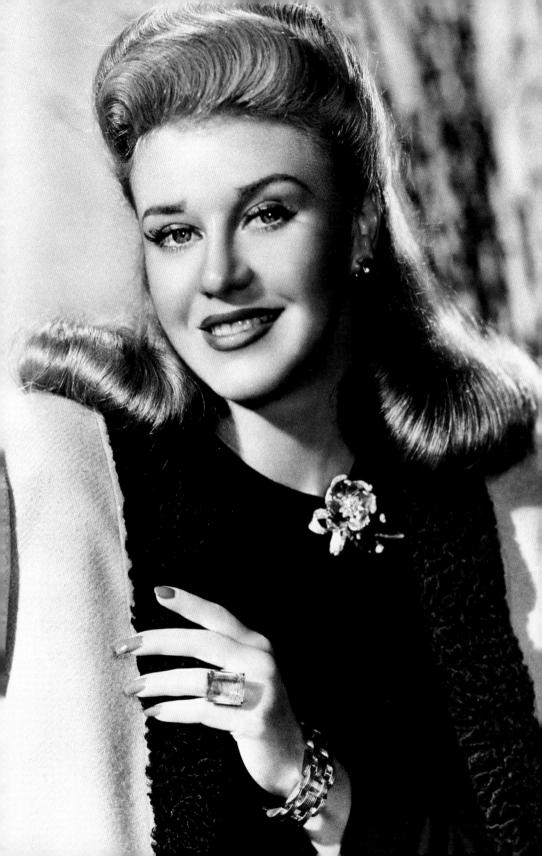

139 (left) Actress Ginger Rogers wears a ring set with a large square gemstone, 1948.

Bettmann/Getty Images

140 Gold ring set with rubies. France, c.1935–40. V&A: M.209–2007. Given by the American Friends of the V&A through the generosity of Patricia V. Goldstein

141 Platinum ring set with an aquamarine, diamonds and rubies.

Made by Bailey, Banks & Biddle Co., Philadelphia, USA, 1930-40.

V&A: M.123-2007. Given by the American Friends of the V&A

through the generosity of Patricia V. Goldstein

142 Platinum ring set with diamonds, sapphires and emeralds. Europe, 1920–30. V&A: M.186-2007. Given by the American Friends of the V&A through the generosity of Patricia V. Goldstein

143 Platinum ring set with baguette- and round-cut diamonds.

Made by Van Cleef & Arpels, Paris, France, 1920–30.

V&A: M.124–2007. Given by the American Friends of the V&A

through the generosity of Patricia V. Goldstein

Rings during and after the Second World War

The privations of wartime took their toll on the jewellery industry in Europe. In Britain the manufacture of jewellery was forbidden from 1 August 1942, apart from some essential items such as wedding rings. The new 'Utility' wedding rings were made of 9-carat gold rather than the traditional 22-carat and could weigh no more than 2 pennyweights (3.12 grammes). Supply of even these rings was limited. Commentators noted that:

Public indignation, especially among servicemen, is quickly rising as the scarcity of wedding rings grows more acute. The social implications of the wedding ring are obvious. Every woman in these islands who marries expects to have one, and denied the public symbol of wedlock few indeed would brave the slings and arrows of their outraged neighbours.⁹

The American sculptor Alexander Calder (1898–1976) designed a creative alternative to the traditional gold ring for the marriage of his friends the artist Audrey Skaling and the architect Stamo Papadaki in 1946, twisting a single strip of silver into a ring with a flat spiral bezel (fig. 144). Calder was best known for his invention of 'mobiles' or kinetic sculptures but he also made jewellery from copper, silver or brass wire.

Diamonds remained fashionable for those who could afford them. Their place on wedding and engagement rings was cemented by a 1947 advertising campaign for the leading diamond company De Beers intended to 'strengthen the tradition of the diamond engagement ring – to make it a psychological necessity'. ¹⁰ Under the slogan 'a diamond is forever', this gemstone became an enduring symbol of commitment.

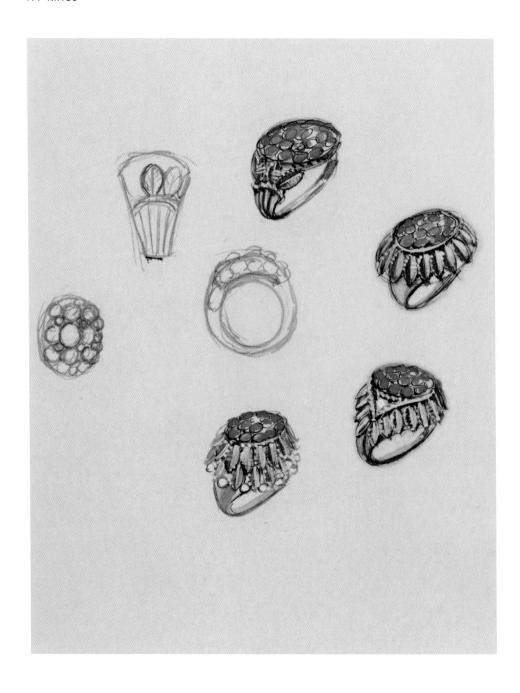

Restrictions on the supply of gold continued in Britain after the war ended in 1945 and this, combined with the punishing rates of purchase tax (collected by the jeweller and added to the purchase price) that peaked at 125 per cent in 1947, slowed the recovery of the jewellery industry. Some wearers, however, rose above restrictions. The poet Edith Sitwell (1887–1964) was famous for her dramatic jewellery: 'I feel undressed without my rings', she told an interviewer for *The Observer* in 1959. If A portrait by Cecil Beaton (1904–80) shows her wearing a group of large rings probably bought from the London jeweller Michael Gosschalk (figs 146–9).

The post-war optimism of the 1950s and the return of luxury and glamour gradually spread to the jewellery industry as clients returned to the major jewellery houses of Europe and America. The ledgers of the Bond Street firm of H. Godman (later Godman and Rabey) show the range of styles available to customers in London (figs 1 and 145). Clients of Chaumet, Boucheron and Asprey chose from a selection of designs supplied by H. Godman to these jewellery houses, and when the final version had been picked out, a record with the confirmed drawing was posted into the firm's ledger, along with the costing for materials and workmanship.

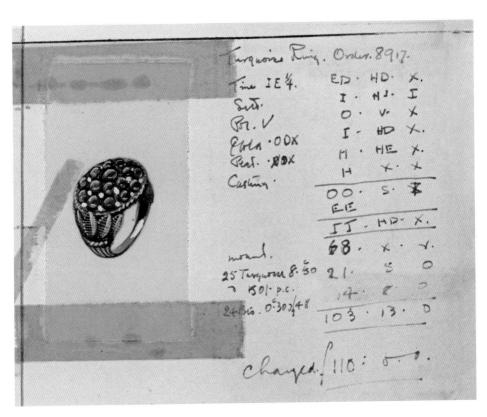

145 (left and above) Designs for a turquoise ring for Boucheron by H. Godman, London, England 1955-60. Various design possibilities are explored for this ring, especially in the arrangement of leaves forming the bezel. The design finally selected by Boucheron was pasted into the workshop ledger along with a coded costing and the final price of £110.

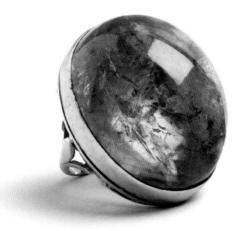

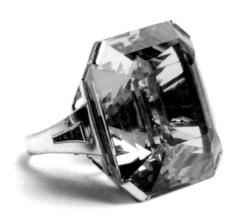

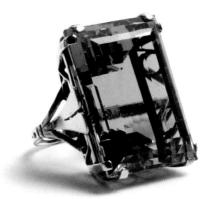

146 (left) Edith Sitwell by Cecil Beaton. She wears her customary rings, some of which are now on loan to the V&A . England, July 1962.
© Cecil Beaton Studio Archive at Sotheby's

147 (above, left) White gold ring set with a table-cut aquamarine and calibré-cut rubies. Made by Michael Gosschalk, London, England, c.1950. V&A: Loan:Met Anon.1-1982

148 (above, middle) Gold ring set with a cabochon amethyst. England, c.1950.

V&A: Loan:Met Anon.3-1982

149 (above, right) Gold ring set with a table-cut aquamarine. Made by Michael Gosschalk, London, England, c.1950.

V&A: Loan:Met Anon.2–1982

CHAPTER SIX

1950-The Present

The 1950s and '60s in Europe saw a desire to break with tradition in architecture, sculpture, painting and jewellery. The first jewellery courses were set up in art colleges, and rings became sculptural objects or 'wearable art'. Artist-jewellers challenged conventions about the place of jewellery in society and explored the possibilities of unusual materials.

Artist–jewellers in the 1960s and 1970s

Jewellers working independently in their studios developed their own styles, outside of mainstream fashion. As a writer in the Daily Telegraph explained in 1967, 'The great divide between modern and traditional jewellery becomes more and more marked." Rings became even larger and more inventive in form. Two 'Wing' rings designed by Saara Hopea-Untracht (1925-84), made in the Ossian Hopea workshop in Finland, stretch across the knuckles to cover the whole hand (figs 151 and 152). Hopea-Untracht, who grew up in a family of goldsmiths, trained in interior design and also worked with furniture, glass and textiles. She was the first jeweller in Finland to make large rings and explained her preference for the style in a 1981 interview: 'I feel an ornament should be highly visible.'2

As one of the first artist-jewellers in Britain, Gerda Flöckinger (b.1927) found few galleries interested in exhibiting her early work. Between 1954 and 1964 she displayed her collection at the Institute of Contemporary Arts, London, an indication of her eventual success in championing jewellery as an art form. In 1971 she became the first contemporary jeweller to have a solo exhibition at the V&A. Over several years

Flöckinger gave three of her rings to the Museum as Christmas presents (fig. 154).

The jeweller Barbara Cartlidge (b.1922) founded the Electrum Gallery in London in 1971 to address the difficulties in exhibiting and selling studio jewellery. Like Gerda Flöckinger, she had come to Britain to escape Nazi persecution in Europe. She became known for her bold jewellery in strong, simple shapes and for her work as a jewellery historian and lecturer (fig. 153).

A sharper-edged and more extravagant visibility characterizes the rings of London's Andrew Grima (1921–2007), their large colourful stones set boldly within dramatic textured settings (fig. 155). It was Grima's love of stones that first inspired him to design:

[In 1948] two dealer brothers arrived at our office with a suitcase of large Brazilian stones – aquamarines, citrines, tourmalines and rough amethysts in quantities I had never seen before. I persuaded my father-in-law to buy the entire collection and I set to work designing. This was the beginning of my career.³

According to the *Daily Telegraph* in 1967, 'rings are probably the first item a tradition-minded woman will experiment with'.⁴ On a ring designed by Jeanne Thé (1941–96), which won third prize in the prestigious De Beers Diamond Engagement ring competition of 1964, tiny tiles of gold – each individually made and soldered together – extend right around the shank (fig. 158). Experimentation extended even to the traditional circular form of the ring, as

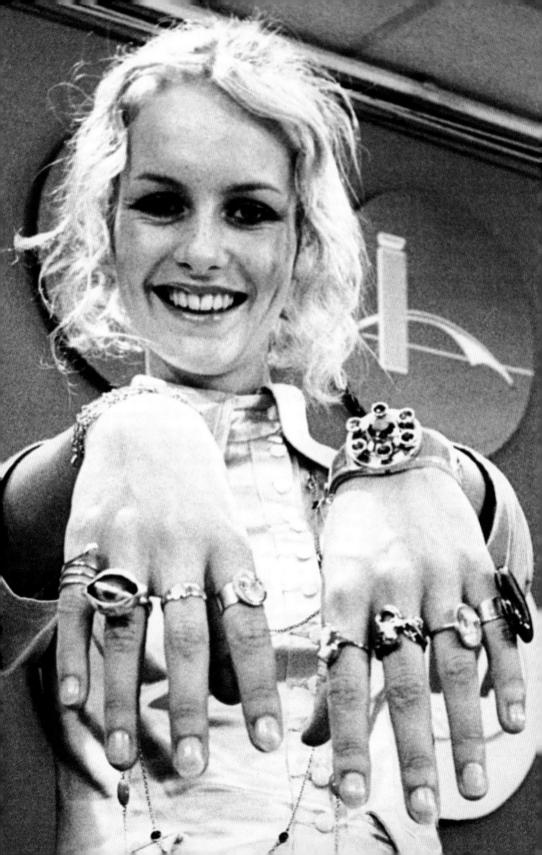

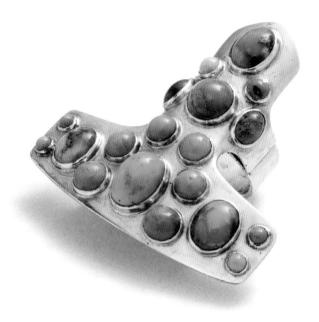

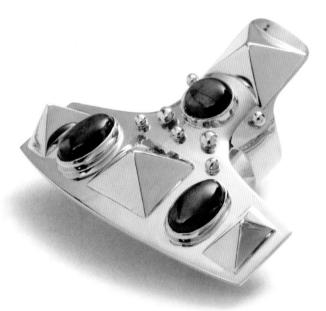

151 'Wing' ring. Gold set with turquoises. Designed by Saara Hopea-Untracht, Porvoo, Finland, 1959–60.

V&A: M.10–2006. Given by Oppi Untracht

152 'Wing' ring. Gold and spectrolite. Designed by Saara Hopea-Untracht, Porvoo, Finland, 1959–60.

V&A: M.9–2006. Given by Oppi Untracht

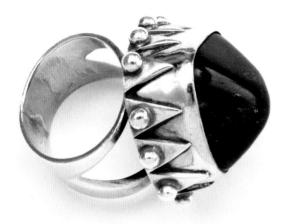

demonstrated by the fact that 'a quarter of the prize-winning designs in the 1968 De Beers Diamond Engagement ring competition are square'.⁵ A double eternity ring by the London firm of Kutchinsky, made in 1961, is traditional in shape, but features an original chevron pattern formed of a double row of baguette diamonds (fig. 156).

Throughout the 1960s and '70s Gillian Packard (1938–97) designed rings described as 'deft, attractive and wearable'.⁶ Her square ring set with diamonds can be worn in either direction and is an inventive response to the traditional diamond ring (fig. 157). Artistically and commercially successful, Packard employed six assistants in her workshop on Neal Street in Covent Garden, London, in 1966, and was the first woman to become a member of the Worshipful Company of Goldsmiths in a professional capacity, rather than through the tradition of family inheritance. ⁷

The 1970s saw the re-establishment of historicism with powerful and informed interpretations of earlier styles by Elizabeth Gage. Her innovative 'Agincourt' design, in which a flexible band of gem-set panels is held by gold chains above and below, dates back to 1967 and is still in production today (fig. 159).

In the 1970s precious metals were combined with acrylic, in unprecedented and daring designs. Fritz Maierhofer (b.1941) had served a traditional apprenticeship in Vienna and worked for a time under Andrew Grima before he began to experiment with this new, colourful and cheap material. Drawing ideas from the London streets around him, he created pieces influenced by the vibrant colours of Pop Art and the neon advertising hoardings of Piccadilly. The standard of craftsmanship, regardless of the value of the materials, bears witness to his rigorous training (fig. 160). This interest in inexpensive materials and a light-hearted approach

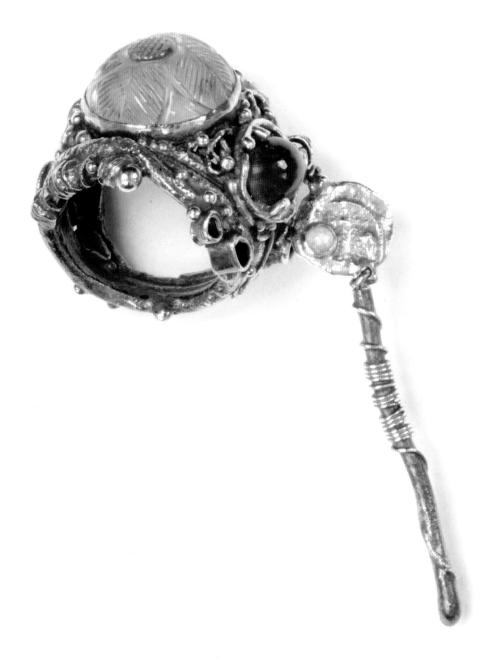

154 Silver and gold ring set with a carved citrine, a tourmaline and an opal.

Designed and made by Gerda Flöckinger, England, 1969.

V&A: Circ.118-1971. © Gerda Flöckinger CBE

can be seen throughout Maierhofer's career, for example in a ring from 2012 made of bright green anodized aluminium, which is part of a series marketed as 'Fritz goes Fashion!' (fig. 161).

The British jeweller Wendy Ramshaw (b.1939) won the Council of Industrial Design Award in

1972 with designs based on geometric forms, and inspired by urban architecture and the space age. She developed the idea of a 'ring set' that allows the wearer to choose the arrangement and orientation of the rings; when not worn, they are displayed on their own turned acrylic stand (figs 162 and 163).

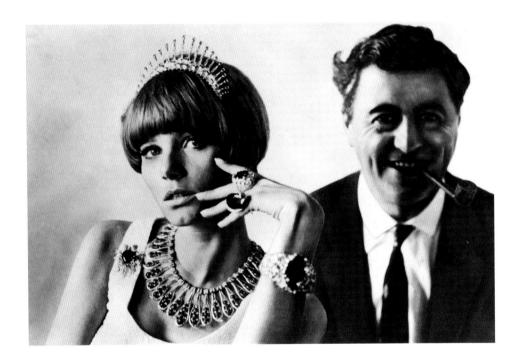

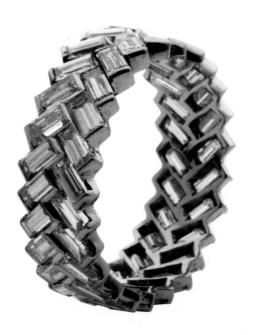

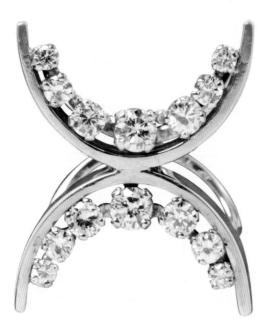

156 Diamond and platinum double eternity ring. Made by Kutchinsky, London, England, 1961. V&A: M.12-2013. Given in memory of Rhoda Golding

157 Gold ring set with diamonds. Designed and made by Gillian Packard, London, England, 1972. Though innovative in form, the ring remains comfortable to wear.

V&A: M.24-1985. © Estate of Gillian Packard

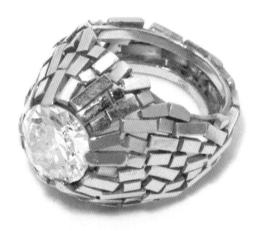

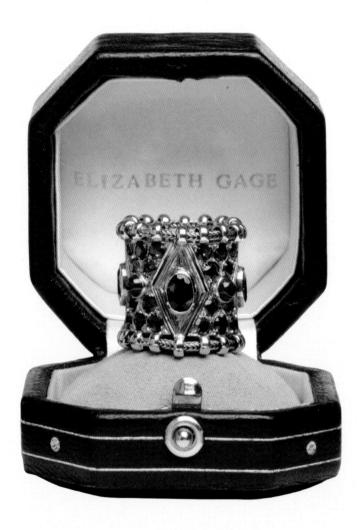

159 Gold 'Agincourt' ring set with rubies and tourmalines. Designed by Elizabeth Gage. Made by Tom Loughridge, London, England, 1979. An early version of this ring won the De Beers Diamond Award in 1972 and was described as 'an engineering masterpiece'.

V&A: M.21:1-2-2010. Given by Elizabeth Gage

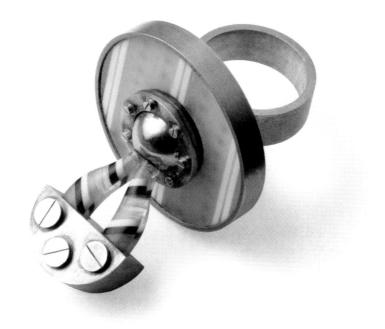

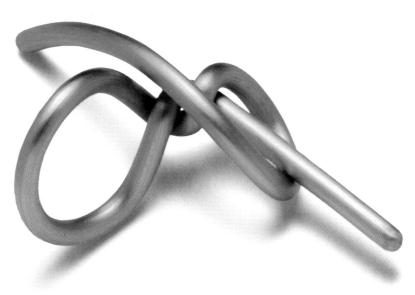

160 Silver and acrylic ring. Designed and made by Fritz Maierhofer, Austria, 1973.

V&A: M.74–1988. © Fritz Maierhofer

161 Anodized aluminium ring. Designed and made by Fritz Maierhofer, Vienna, Austria, 2012. V&A: M.8–2013. Anonymous gift

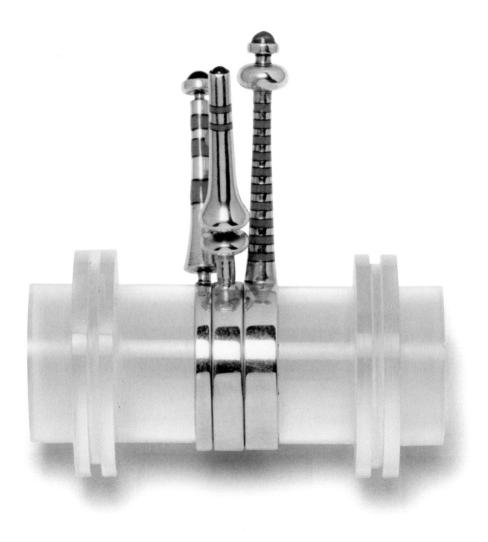

162 Enamelled gold rings set with garnets and carnelians, sit on a turned acrylic stand. Designed and made by Wendy Ramshaw, London, England, 1971.

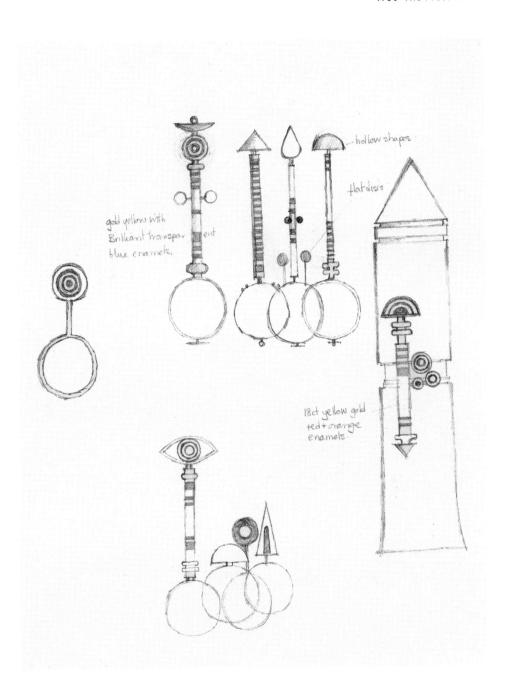

163 Designs for rings and a ring set by Wendy Ramshaw. England, 1977. V&A: E.1174–1978. Given by Wendy Ramshaw

Rings from the 1980s onwards

Artist-jewellers designed rings that were a free expression of their art. Abstract, geometric, figurative and narrative approaches were all used. The rings of British goldsmith Kevin Coates (b.1950) unite technical brilliance with poetic inspiration drawn from mythology, literature and magic: in one ring Caliban, escaping from the pages of Shakespeare's play The Tempest, gazes balefully from between his hands (fig. 165). The work of the American designer Harold O'Connor (b.1941) is characterized by his interest in surface textures. He has a particular fondness for spectrolite, a type of feldspar discovered in Finland in 1938 that reveals brilliant hues when lit from an angle (fig. 164).

Many modern and contemporary rings blur the distinction between jewellery and sculpture. A lignum vitae and silver ring by David Hensel (b.1945) is smoothly polished and tactile. He

describes his jewellery as 'hand-held sculptures which I couldn't put down' (fig. 166). The 'Black Hoopoe Ring' by Charlotte de Syllas (b.1946) was inspired by hoopoe birds in Delhi and shows her mastery of hardstone carving (fig. 167).

Rings can express biographical and philosophical preoccupations, together with humour, wit and social criticism. The American Barbara Walter described her rings as visual translations of puns inspired by fragments of conversation or daydreams; one playful ring designed by her allows the wearer to alter the arrangement of the figures at will (fig. 168). On a ring designed by Charlotte de Syllas, a diamond from the wedding ring of the client's mother, set topside down, resulted in a gem reminiscent of charms against the evil eye (fig. 169). The German goldsmith Gerd Rothmann (b.1941) pressed his own fingerprints, the unique mark of the individual, into wax to form the surface of a ring (fig. 171). The Swiss jeweller Bernhard Schobinger (b.1946)

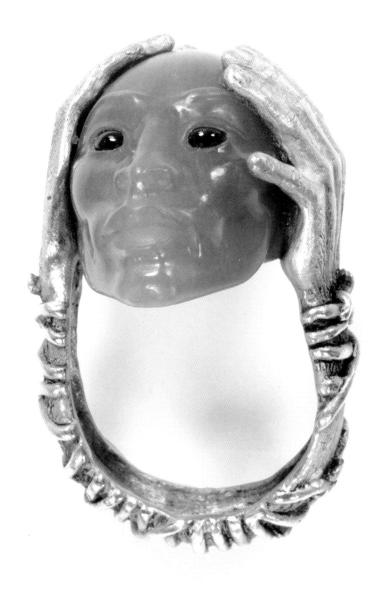

165 'Caliban' ring. Cast gold set with carved grey moonstone and rubies. Designed and made by Kevin Coates, England, 1985.

V&A: M.11-1986

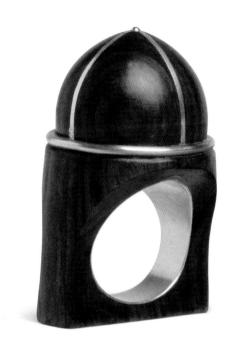

166 Silver and lignum vitae ring. Designed and made by David Hensel, England, 1980. This ring was turned on the lathe from a single piece of wood.

V&A: M.2-2013. Given by David Hensel

167 'Black Hoopoe Ring'. Edwards black jade, white jadeite and platinum. Designed and made by Charlotte de Syllas, England, 1990. V&A: M.215-2011. Given by Gulderen Tekvar

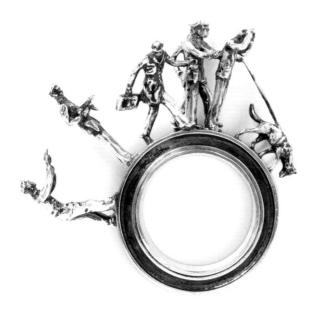

168 'The Big Crime Ring' (Size 13 ½). Silver and steel. Designed and made by Barbara Walter, USA, 1983. V&A: M.40-1984. © Barbara Walter

169 White gold ring set with rock crystal and diamond. Designed and made by Charlotte de Syllas, England, 1990–1. V&A: M.17:1-2008. Given by Gulderen Tekvar in memory of her mother

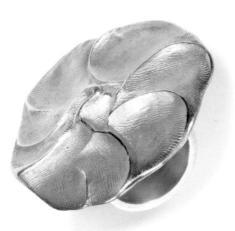

170 'Nose ring'. Partly patinated silver and gold. Designed and made by Louis Mueller, USA, 1996. Mueller often uses puns and visual jokes to create humorous jewellery.
V&A: M.29-1996. Given by the American and International Friends of the V&A through the generosity of Franklin and Susie Parrasch. © Louis Mueller

171 'Mit den Fingerkuppen in Wachs modelliert' ('Modelled in Wax with Fingertips'), silver ring impressed with fingerprints. Designed and made by Gerd Rothmann, London, England, 1993–4.

V&A: M.41-2007. Royal College of Art Visiting Artists Collection

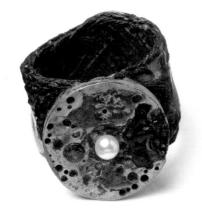

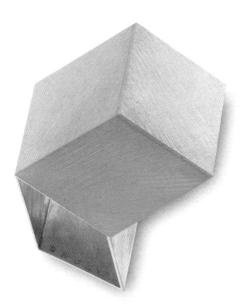

172 'Uhrfragment' ('Watch fragments'). Braided metal wire and fragments of watch plate and jewels set with a pearl. Designed and made by Bernhard Schobinger, Switzerland, 2001.

V&A: M.49-2014. The Louise Klapisch Collection, given by Suzanne Selvi

173 Gold ring. Designed and made by Giampaolo Babetto, Italy, 1981. Babetto studied at the Istituto Pietro Selvatico, Padua, whose members are notable for their modern use of gold.

The ring's precise geometry contrasts with its sensuous gold surface.

V&A; M.47-1990. Courtesy of Giampaolo Babetto/Photo: Giustino Chemello, Vicenza

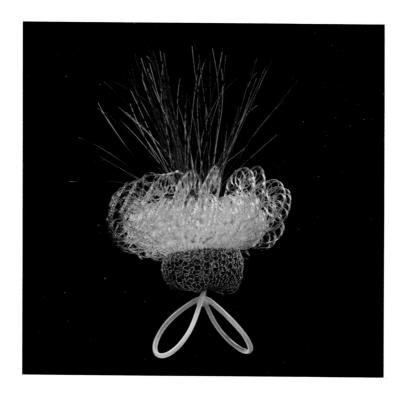

combines a traditional jewellery training with an interest in challenging and unconventional materials. His 'Uhrfragment' ring (fig. 172) is formed of the distressed and damaged fragments of a watch set with a single, shining pearl.

Nature is an inspiration for many jewellers, including the Austrian-born Elisabeth Kodré Defner (b.1931), who, during her residency at the Royal College of Art, London, transformed a leaf found in Hyde Park into a ring through lost-wax casting (fig.175). 'Centaurea cyanus', part of the 'Nylon Botanicus' series by Nora Fok (b.1952), was inspired by a cornflower (fig. 174). Jacqueline Ryan (b.1966) and Barbara Paganin (b.1961; fig.176) both begin each project with a careful examination of the natural world, and through sketches and detailed designs draw on the patterns inherent in nature to create their

rings. For a gold and enamel ring made in 2007, Ryan took inspiration not from a flower but from its life-generating stamens (fig. 180). As she explains, it is 'the interaction of the wearer with the work which truly brings the piece to life'. 9

The grey gold and silver 'Fleurs de zinc' ring by Fabrice Schaefer (b.1969) is also inspired by plant life but is reminiscent of a plant's roots as much as its flower. The metal is oxidized to give a subtle, almost industrial effect (fig. 181). A ring by Mari Ishikawa (b.1964) is made of a roughly formed silver leaf entwined in gold wire; the silver colour was chosen to convey the dreamlike impression of the plant seen by moonlight (fig. 178). Zoe Arnold's ring considers the parallels between human destiny and the short life of flies which 'turn and waltz their last upended hours'. ¹⁰ Her golden flies hover over a field of green garnet crystals (fig. 183).

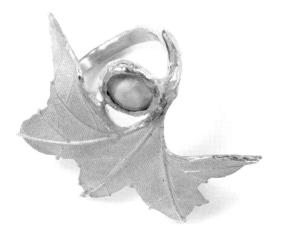

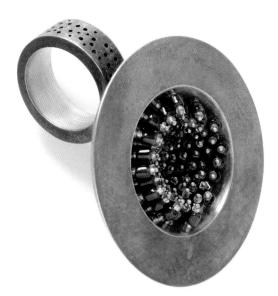

175 Partially gilded silver ring set with an opal triplet. Designed and made by Elisabeth Kodré Defner, London, England, 1990-1. Kodré Defner's jewellery unites her appreciation of nature with an interest in the properties of gemstones and crystals.

V&A: M.29-2007. Royal College of Art Visiting Artists Collection

176 Silver and gold ring set with almandine garnets and glass beads. Designed and made by Barbara Paganin, London, England, 2001-2. From a series based on fruit and vegetables, the ring features glass beads threaded onto gold rods that move gently with the hand.

V&A: M.66-2007. Royal College of Art Visiting Artists Collection

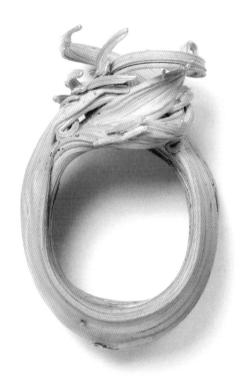

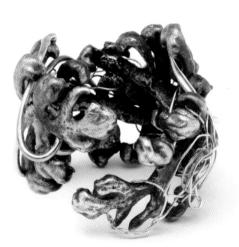

177 Cast gold ring. Designed and made by Karl Fritsch, London, England, 2002–3. The gold has an almost organic quality, reflecting Fritsch's motto:
 'I would like to treat gold in the same way as plasticine.'
 V&A: M.70-2007. Royal College of Art Visiting Artists Collection

178 'Moonlight shadow' ring. Oxidized silver and gold wire. Designed and made by Mari Ishikawa, Germany, 2008. V&A: M.35-2014. The Louise Klapisch Collection, given by Suzanne Selvi

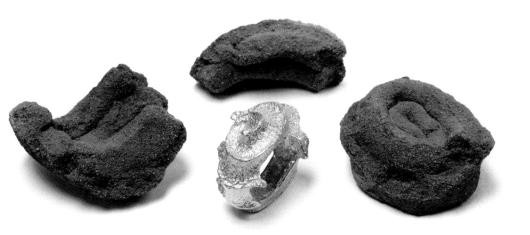

179 Gold ring with fragments of clay mould. Designed and made by Johanna Dahm, Switzerland, 2006. Dahm used the African Ashanti closed-cycle casting method to make this ring.

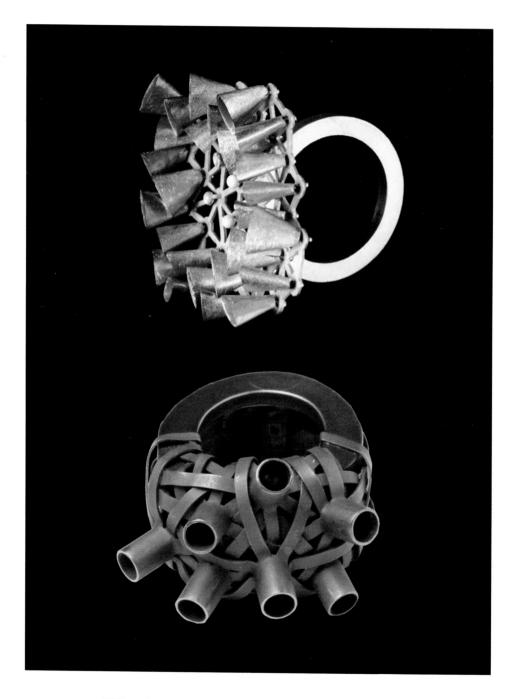

180 Enamelled gold ring. Designed and made by Jacqueline Ryan, Italy, 2007. V&A: M.47–2009. Given by Jacqueline and Jonathan Gestetner

181 'Fleurs de zinc' ring. Grey gold and oxidized silver. Designed and made by Fabrice Schaefer, Switzerland, 2000.
V&A: M.46-2014. The Louise Klapisch Collection, given by Suzanne Selvi

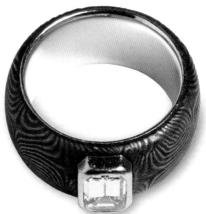

Landscape and the natural world were also the impetus for a ring designed by Romilly Saumarez Smith with Lucie Gledhill. The design was inspired by the exposed roots under a circle of cut turf seen on a Newfoundland island. The effect was created by threading tiny gold discs and diamond beads onto wire (fig. 184).

The design for the 'Savannah' ring by the London jewellers Wright & Teague comes from the grasslands of Africa. The simple, elegant form is based on that of a pebble wrapped with a blade of grass (fig. 185). The ring by Johanna Dahm (b.1947) was also based on an African idea. It was made with a technique used by the Ashanti goldsmiths of Ghana: molten gold is poured into a carved clay mould and chance dictates the finished design, revealed only when the clay is broken open (fig. 179).

The sculptural curled gold ring by Ute Decker (b.1969) is the first piece of fair trade jewellery acquired by the V&A. Internationally agreed Fairtrade Standards guarantee a living wage and safe working conditions to the miners who extract the gold used to make the ring, and demonstrate how jewellers and their customers

are showing a new appreciation for ethical consumption (fig. 186).

A pair of modern wedding rings by Roger Doyle (b.1947) was created by lining steel from a shotgun with gold, a technique pioneered by Malcolm Appleby (b.1946), who supplied the steel (fig. 182). Training as a sculptor and a fascination with colour are apparent in the intricately constructed pieces of Peter Chang (b.1944), which often use recycled materials such as bicycle reflectors (fig. 189). The irreverent jewellery of Solange Azagury-Partridge (b.1961) has been embraced by the world of celebrities and fashion. Her 'Hotlips' ring reflects the earthy, sensual side of life and exists in various colours, including a ruby-encrusted version (figs 190 and 191).

From the starting point of a hoop around the finger, contemporary jewellers have opened up a world of invention. Rings can be playful, sculptural, glamorous or challenging, made of precious materials or the most humble everyday substances, and constrained only by the imagination of their makers and wearers.

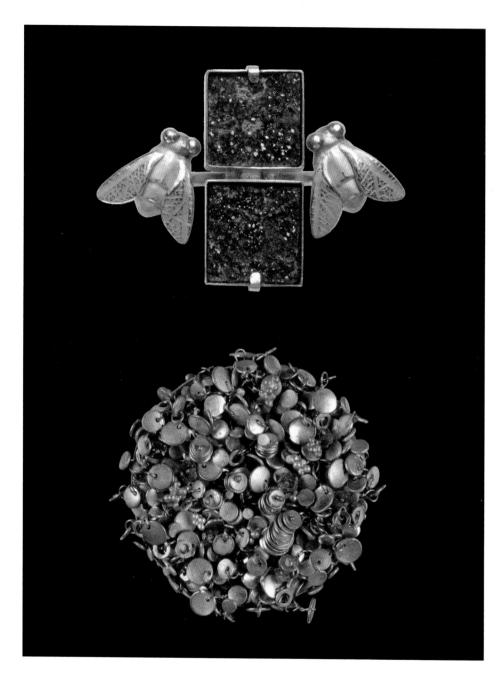

183 'Destiny' ring. Gold and uvarovite garnet. Designed and made by Zoe Arnold, England, 2011. V&A: M.15-2012. Given by Jacqueline and Jonathan Gestetner

184 'Landscape ring'. White and yellow gold and diamonds. Designed by Romilly Saumarez Smith with Lucie Gledhill, London, England, 2012.

V&A: M.4-2013. Given by Linda L. Brownrigg

185 Gold 'Savannah' ring. Designed and made by Wright & Teague, London, England, 2010. V&A: M.40–2010. Given by Gary Wright and Sheila Teague

186 'The curling crest of a wave' ring. Designed and made by Ute Decker, London, England, 2015. Ute Decker was one of the first UK jewellers to specialize in using gold of the Fairtrade Standard, which guarantees fair wages and safe working conditions for miners.

V&A: M.2-2016. Given by Jacqueline and Jonathan Gestetner

187 Gold ring set with a diamond. Designed and made by Shaun Leane,
London, England, 2007.

V&A: Loan:Leane.1-2007. © Shaun Leane

188 'Raindance' ring. Platinum set with diamonds. Made by Boodles, England, 2009. V&A: M.52-2009. Given by Boodles

189 Acrylic and bronze ring. Designed and made by Peter Chang, Liverpool, England, 2007. V&A: M.9-2008. Supported by the Friends of the V&A

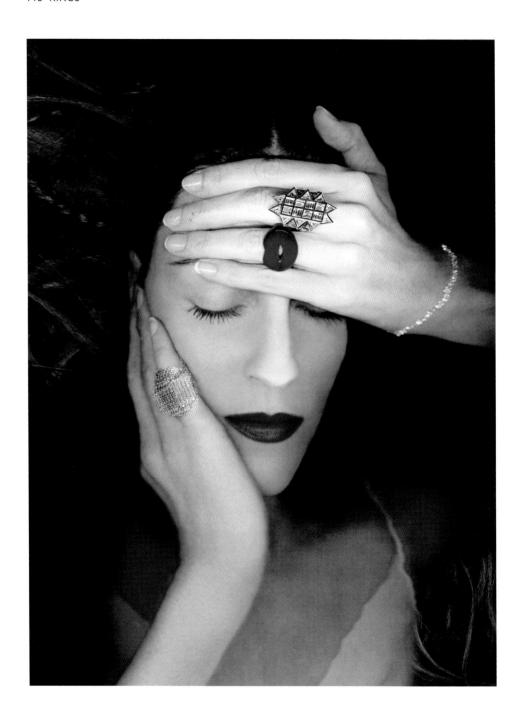

190 Publicity photograph for the jewellery of Solange Azagury-Partridge. Model Susie Cave wears 'Witchy', 'Hotlips' and 'Flat Fringe' rings, and a diamond-beaded bracelet.

Photo Katerina Jebb

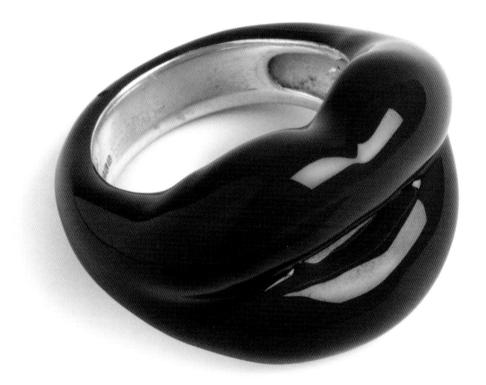

Glossary

1. Parts of a ring:

Bezel – The upper part of the ring hoop. It can consist of a flat table, be engraved with a design or have a setting for gemstones.

Hoop or shank – The portion of the ring that encircles the finger.

Shoulder – The part of the ring joining the hoop with the bezel.

2. Other terms:

Baguette-cut – A step-cut gemstone in a long, rectangular shape.

Brilliant cut – A round diamond cut with 58 facets, 33 on the upper section of the stone and 25 on the lower section. In general use by the 19th century, a brilliant cut is characterized by its superior refractive quality.

Cabochon – A stone that has been polished smooth rather than cut into facets.

Calibré cut – A method of cutting gemstones so that they fit exactly into their setting without visible metal support.

Chasing -A method of creating a design on metal by working it from the front of the piece with shaped hammers and punches.

Claddagh ring –A ring with the bezel in the form of two hands clasping a crowned heart.

Claw setting -A method of setting a stone in which metal claws or prongs are drawn over the edges of the stone to hold it in place.

Enamel – A substance formed from coloured glass powder fused onto a metallic surface.

Fede ring –A ring with two clasped hands, sometimes holding a heart, from the Italian mani in fede ('hands [joined] in trust').

Giardinetti ring – A ring with the bezel in the form of a flower-pot, meaning 'little garden'.

Gimmel ring – A ring formed of two or three interlocking hoops, often used as a token of love or wedding ring, from the Latin *gemellus*, meaning 'twin'.

Gypsy setting – A method of setting a stone in which the stone is flush with the surface of the metal and the metal is drawn over it in small prongs to hold it in place.

Intaglio – A design cut into a flat metal or hardstone surface, for example to create an impression for a seal.

Lapidary - A treatise or book describing the qualities of gemstones and their supposed medicinal, magical or amuletic uses.

Marquise or navette – A pointed oval shape used as a bezel in the 18th and 19th centuries.

Memento mori - A Latin phrase that translates as 'Remember you must die'. Used to describe rings and other objects decorated with emblems relating to death, such as skulls, hourglasses, and coffins, to remind the wearer to prepare his or her soul for death.

Merchant's mark – A distinctive geometric symbol, often based around the number 4, used to mark goods and to identify a merchant. It can be found as a personal identifier on signet rings, gravestones and stained-glass windows, and as a replacement for heraldry.

Micro-mosaic – Decoration formed by making a design of very small enamel or glass pieces.

Nicolo – Onyx carved so that a bluish layer of the stone lies above a darker background.

Niello – A black mixture of copper, silver and lead sulphides used to create a decorative design when inlaid into metal.

Openwork – A technique of jewellery production or decoration involving piercing or punching holes through the material.

Paste - A substitute for precious stones made from a glass compound.

Point cut – A pyramidal diamond cut that uses the natural shape of a diamond.

Posy ring - A ring engraved with a short romantic verse, known as a posy.

Quatrefoil - A bezel shaped as a flower with four petals.

Rosecut – A pointed diamond cut with a flat base, often made up of 24 triangular facets. Developed before the brilliant cut, the rose cut involves less wastage of stone, but achieves less sparkle.

Round cut - A type of brilliant cut (see above) which is perfectly symmetrical.

Signet ring – A ring engraved with a coat of arms, initials, a personal device or a merchant's mark which could be pressed into wax to serve as a signature or sign of authenticity.

Silver-gilt – Silver which has been coated with a thin layer of gold.

Table cut – One of the earliest styles of gem-cutting, in which the upper part of the stone is removed to leave a large rectangular facet surrounded by a bevelled edge or smaller facets.

Tau cross – A T-shaped cross associated with St Anthony and believed to protect against ergotism, or poisoning from rye grain infected with the ergot fungus.

Toadstone – The fossilized tooth of the prehistoric fish *Lepidotes*, believed to protect against poison and venomous bites.

Further Reading

Bury, Shirley, Introduction to Rings (London, 1984)

Campbell, Marian, *Medieval Jewellery* (London, 2009)

Chadour, Beatriz, Rings: The Alice and Louis Koch Collection (Leeds, 1994)

Cherry, John et al., *The Ring* (London, 1981)

Dalton, O.M., Catalogue of the Finger Rings, Early Christian, Byzantine, Teutonic, Medieval and Later in the British Museum (London, 1912)

Henig, M. and Scarisbrick, D., Finger Rings from Ancient to Modern (Oxford, 2003)

Oman, Charles, Catalogue of Rings in the Victoria and Albert Museum (London, 1930, reprinted Ipswich, 1993)

Phillips, Clare, Jewels and Jewellery (London, 2000, revised 2008)

Pointon, Marcia, Brilliant Effects: A Cultural History of Gem Stones and Jewellery (New Haven and London, 2009)

Scarisbrick, Diana, Rings: Symbols of Wealth, Power and Affection (London, 1993)

—, Historic Rings: Four Thousand Years of Craftsmanship (Tokyo, 2004)

—, Rings: Jewellery of Power, Love and Loyalty (London, 2007)

Notes

Introduction

 Old Bailey Proceedings Online (www.oldbaileyonline.org, accessed 16 October 2016), January 1761, trial of John Leigh (t17610116-5)

Chapter One: 1200-1500

- 1 Margaret Wade Labarge, Mistress, Maids and Men: Baronial Life in the Thirteenth Century (London, 1965, reprinted 2003), p. 145
- 2 Ibid.
- 3 John Jay Parry, The Art of Courtly Love: With Introduction, Translation and Notes (New York, 1941), p. 176
- 4 Diamond Trading Company, *Diamonds* and the Power of Love (London, 2002), p. 16
- 5 A. Stewart (ed.), The Book of the Wanderings of Felix Fabri (Palestine Pilgrims Text Society, 1882–97), vol. I, part 1, p. 93
- 6 Sally J. Cornelison, 'A French King and a Magic Ring: The Girolami and a Relic of St Zenobius in Renaissance Florence', Renaissance Quarterly (2002), vol. LV, pp. 434-69
- 7 Joan Evans, Magical Jewels of the Middle Ages and the Renaissance Particularly in England (London, 1922, reprinted 2004), p. 126
- 8 Eamon Duffy, The Stripping of the Altars: Traditional Religion in England 1400–1580 (London, 1992), p. 274
- 9 Christopher J. Duffin, 'Fossils as Drugs: Pharmaceutical Palaeontology', Ferrantia (2008), vol. LIV, p. 43

Chapter Two: 1500-1700

- 1 Scarisbrick 1993, p. 42
- 2 John Donne, *The Complete English Poems*, ed. Albert Smith (London, 1996), p. 279

- 3 Alec Ryrie, The Sorcerer's Tale (Oxford, 2008)
- 4 Mary E. Hazard, *Elizabethan Silent* Language (Nebraska, 2000), p. 115
- 5 Jackson Campbell Boswell, 'Shylock's Turquoise Ring', Shakespeare Quarterly (Autumn 1963), vol. XIV, no. 4, pp. 481-3
- 6 M. Ajmar-Wollheim and F. Dennis (eds), At Home in Renaissance Italy (London, 2006), p. 110
- 7 Diamond Trading Company (cited note 4, 1200–1500), pp. 12–13
- 8 William M. Schutte, 'Thomas Churchyard's "Dollful Discourse" and the Death of Lady Catherine Grey', *The Sixteenth Century Journal* (Winter 1984), vol. XV, no. 4, pp. 471–87
- 9 David Cressy, Birth, Marriage and Death: Ritual, Religion, and the Life Cycle in Tudor and Stuart England (Oxford, 1997), p. 345
- 10 Sir Thomas Browne, Pseudodoxia Epidemica IV (1646, sixth edition 1672), chapter IV ('Of the Ring finger')
- 11 Ibid.
- 12 John William Burgon, *The Life and Times of Sir Thomas Gresham*, vol. I (London, 1839), pp. 51–2
- 13 Old Bailey Proceedings Online (www.oldbaileyonline.org, accessed 16 October 2016), July 1737, trial of Hans MacConnel (t17370706-16)
- 14 Old Bailey Proceedings Online (www.oldbaileyonline.org, accessed 16 October 2016), 8 November 1738, Ordinary's Account (OA17381108)
- 15 Schutte (cited note 8), pp. 471-87
- 16 Robert Hill, The Pathway to Prayer and Pietie, 1610, quoted in Cressy (cited note 9), p. 389
- 17 William Shakespeare, Henry IV, Part 2, II, iv
- 18 Diary of Samuel Pepys, Saturday 13 April 1661 (www.pepysdiary.com, accessed 16 October 2016)

- 19 Memoirs of the Verney Family, 1642–96, vol. IV, p. 327; quoted in P. Cunington and C. Lucas, Costume for Birth, Marriage and Death (London, 1972), p. 192
- 20 Clare Gittings, Death, Burial and the Individual in Early Modern England (London, 1988), p. 81
- 21 J.H. Baker (Selden Society), The Order of Serjeants at Law (London, 1984), p. 94, quoted in Mark Emanuel, The Surviving Rings of the Serjeants at Law, 2008, private publication (copy held in the Metalwork Department library, Victoria and Albert Museum)
- 22 Robert de Berquen, Merveilles des Indes Occidentales et Orientales, 1661, quoted in D. Scarisbrick, C. Vachaudez and J. Walgrave (eds), Brilliant Europe: Jewels from European Courts (Brussels, 2007), p. 125
- 23 Sir Thomas Peyton of Knowlton and their circle, The Oxinden and Peyton Letters 1642–1670: Being the Correspondence of Henry Oxinden of Barham (London, 1937), p.190

Chapter Three: 1700-1820

- 1 Pointon, Marcia, Brilliant Effects: A Cultural History of Gem Stones and Jewellery (New Haven and London, 2009)
- Old Bailey Proceedings Online (www.oldbaileyonline.org, accessed 16 October 2016), January 1742, Ordinary's Account (OA17420113)
- 3 Pointon 2009, p. 58
- 4 Martha Gandy Fales, Jewelry in America 1600–1900 (Suffolk, 1995), p. 31
- 5 Old Bailey Proceedings Online (cited note 1, Introduction)
- 6 Ida Delamer, 'The Claddagh Ring', Irish Arts Review Yearbook (1996), vol. XII, pp. 181–7
- 7 Old Bailey Proceedings Online (www.oldbaileyonline.org, accessed 16 October 2016), May 1790, trial of Thomas Hopkins (t17900526-1)

- 8 Old Bailey Proceedings Online (www.oldbaileyonline.org, accessed 16 October 2016), December 1706, trial of Robert Fielding (t17061206-1)
- Jane Austen, Northanger Abbey (1817), ch. 15
- 10 Jane Roberts (ed.), George III and Queen Charlotte: Patronage, Collecting and Court Taste (London, 2004), cat. 442
- 11 Diana Scarisbrick, Jewellery in Britain: 1066–1837 (Norwich, 1994), p. 339
- 12 Marcia Pointon, Strategies for Showing: Women, Possession and Representation in English Visual Culture 1665–1800 (Oxford, 1997), p. 373
- 13 Ibid., p. 382
- 14 The last will and testament of George Mason, www.virginia1774.org/ GeorgeMasonWill.html, accessed 16 October 2016
- 15 Alice Morse Earle, Customs and Fashions in Old New England (Gloucestershire, 2009), p. 200
- 16 The chocolate cups are now in the British Museum, MLA 2005,6–4.1 and 2.
- 17 Scarisbrick 2007, p. 179
- 18 Email correspondence between Clare Phillips and Mary Fraser, 20 September 2009.
- 19 Simon Bendall, 'A Group of Mourning Rings', *Jewellery Studies* (2008), vol. XI, pp. 91–103
- 20 Old Bailey Proceedings Online (cited note 4)
- 21 Christopher Hibbert, George III: A Personal History (London, 1999), p. 394
- 22 Trade label on the back of a portrait of Isabella Burrell (V&A: P.82-1929)
- 23 Johann Kaspar Lavater, Physiognomische Fragmente zur Beförderung der Menschenkenntnis und Menschenliebe (1775–8)

Chapter Four: 1820-1900

- 1 Simon Jervis, Art and Design in Europe and America, 1800–1900 (London, 1987), p. 80
- 2 Geoffrey Munn, Castellani and Giuliano: Revivalist Jewellers of the 19th Century (New York, 1984), p. 117
- 3 Scarisbrick 1993, p. 164
- 4 Catalogue of a Collection of Ancient and Medieval Rings and Personal Ornaments Formed for Lady Londesborough (London, 1853), quoted in Tetzeli von Rosador, 'Gems and Jewellery in Victorian Fiction', R.E.A.L. (1984), vol. II, pp. 275–318
- 5 William Makepeace Thackeray, Pendennis (1848), quoted in von Rosador (cited note 4)
- 6 O. Collings and G. Reddington, *Georgian Jewellery*, 1714–1830 (London, 2007), p. 88
- 7 Pat Jalland, Death in the Victorian Family (Oxford, 1996), pp. 298–9
- 8 Scarisbrick 1993, p. 166

Chapter Five: 1900-1950

- Obituary in The Apple (of beauty and of discord), 1920, p. 174
- 2 Pearson would later be reported missing, presumed killed, near Hooge, Belgium, on 16 June 1915.
- 3 Jeweller and Metalworker (15 August 1925), p. 1160
- 4 'The Mode in Jewellery', Goldsmiths Journal (September 1928), pp. 826-7
- 5 Melissa Gabardi, Jean Després: Jeweller, Maker and Designer of the Machine Age (London, 2008), p. 110
- 6 Clare Phillips, 'Art Deco Jewellery', in C. Benton, T. Benton and G. Wood (eds), Art Deco: 1910–39 (London, 2003), p. 279
- 7 Gilles Chazal, The Art of Cartier (Paris, 1989), p. 93
- 8 Michael Batterberry, Fashion: The Mirror of History (London, 1982), p. 319

- Shena Mason, Jewellery Making in Birmingham 1750–1995 (Chichester, 1998), p. 137
- 10 Edward Jay Epstein, 'Have You Ever Tried to Sell a Diamond?', The Atlantic Magazine (February 1982)
- 11 Edith Sitwell, 'My Clothes and I', The Observer (18 May 1959), p. 19

Chapter Six: 1950–The Present

- Nicola Hemingway,
 'Rings on All her Fingers', Daily Telegraph
 (27 March 1967), p. 5
- 2 Oppi Untracht, Saara Hopea-Untracht: Life and Work (Helsinki, 1988), p. 190
- 3 Veronica Horwell, obituary for Andrew Grima, The Guardian (18 January 2008), p. 42
- 4 Hemingway (cited note 1)
- 5 'Square Shank Rings Theme for '68?', Retail Jeweller (24 April 1968)
- 6 Peter Hinks, Twentieth-Century British Jewellery 1900–1980 (London, 1983), p. 132
- 7 Fiona MacCarthy, 'A Short Guide to Modern British Jewellery', *The Guardian* (4 November 1966)
- 8 Personal communication with Rachel Church, 2013
- 9 www.jacqueline-ryan.com/sketchbooks. htm, accessed 26 October 2016
- 10 Zoe Arnold, 'The Destiny of Flies', 2011

The Origins of the V&A's Collection

- 1 Julia Blackburn, Charles Waterton, 1782–1865: Traveller and Conservationist (London, 1989), p. 162
- 2 'Dactyliotheca Watertoniana: A Descriptive Catalogue of the Finger-rings in the Collection of Mrs. Waterton' (manuscript), 1866, now in the National Art Library, London
- 3 Blackburn (cited note 2), p. 215

The Origins of the V&A's Collection

The collection of rings at the Victoria and Albert Museum (V&A), London, owes its richness to many collectors and donors. One of the earliest influences on the Museum's ring collection was Edmund Waterton (1830-87), son of the naturalist and taxidermist Charles Waterton. Conscious of the standards expected of 'a person of my background and reputation', Edmund rejected his father's eccentric and ascetic lifestyle in favour of every sort of fashionable entertainment. He bought rings 'compulsively and entirely reckless of cost',1 recording their histories in his unpublished 'Dactyliotheca Watertoniana'.2 After what contemporaries described as a 'brief career of pride and folly and extravagance', he ran into debt and was compelled to sell his family home and pawn his collection of more than 600 rings.3

The rings bequeathed by the Reverend Chauncey Hare Townshend (1798-1868), collected as interesting gems rather than as wearable accessories, show the range of gemstones used in jewellery. Aside from his interest in jewels, Townshend was an enthusiastic spiritualist and a friend of Charles Dickens, who dedicated the novel Great Expectations to him. This group of 145 rings is of particular interest as it was formed before many of the techniques for artificially improving the colour and appearance of gemstones became widespread. A number of Townshend's rings, including the eight principal diamond rings, came from the collection of Henry Philip Hope (1774-1839), who owned the celebrated Hope Diamond now in the National Museum of Natural History, part of the Smithsonian Institution, Washington, DC.

Dame Joan Evans (1893-1977) was a pre-eminent donor to both the ring and the jewellery collections. A renowned historian, antiquarian and jewellery collector, she was given by her half-brother, the archaeologist Sir Arthur Evans, the rings collected by their father, Sir John Evans, in gratitude for compiling the index of Sir Arthur's history of the Palace of Minos in Crete. The collection included a particularly rich group of medieval and posy rings (see p. 41). She added to it and completed a series of generous lifetime donations in 1975, graciously thanking the V&A Metalwork Department, which 'has been kind to me for 65 years'.

The representation of 20th-century rings owes much to the generosity of Patricia V. Goldstein (1930–2002), whose lifetime of collecting and dealing in jewellery was crowned by the gift of her collection shortly before her death to the American Friends of the V&A. The archive of the London firm of Godman and Rabey, generously donated by Alan Rabey (b.1932), shows us the workings of a Bond Street jewellery firm and its relationship with major jewellery houses including Chaumet and Boucheron (figs 1 and 145).

The Royal College of Art's Visiting Artists programme, pioneered by Professor David Watkins from 1987 to 2006, allowed many notable international artist-jewellers to work with students at the college in London. Each created a jewel during their visit and the acquisition of the resulting collection by the V&A transformed its holdings of contemporary rings. Other innovative rings joined the Museum when the collection of contemporary jewellery put together by Louise Klapisch (d.2012) was donated by her sister Suzanne Selvi in 2014. The V&A rings collection continues to grow, often thanks to generous donors, and it is also enriched and kept current by purchases from contemporary jewellery galleries and craft fairs.

No collection is ever complete and the V&A rings collection grows yearly, often thanks to our generous donors.

Major Collections Featuring Rings

Victoria and Albert Museum, London, UK
British Museum, London, UK
Museum of London, London, UK
Ashmolean Museum, Oxford, UK
National Museum of Scotland, Edinburgh, UK
Musée des Arts Décoratifs, Paris, UK
Schmuckmuseum, Pforzheim, Germany, UK
Alice and Louis Koch collection at the National Museum,
Zurich, Switzerland
Nordiska Museet, Stockholm, Sweden
Museum für Angewandte Kunst, Cologne, Germany

Acknowledgments

I owe my gratitude to many people – to Richard Edgcumbe and Beatriz Chadour-Sampson first of all, for all their help, advice and encouragement, and for reading many versions of the text with great patience. Clare Phillips provided invaluable help and advice and Veronica Bevan worked tirelessly cross-referencing images. Any remaining errors in fact or judgement are entirely my own. To Dominic Naish, lan Thomas and Richard Davis for the wonderful photographs, and to Jo Whalley for her work in identifying the gemstones and gemmological advice. Thanks must go to Tessa Murdoch and all my colleagues in the Metalwork section of the Sculpture, Metalwork, Ceramics and Glass Department for their support. Many thanks to Charlotte Heal, Laura Lappin, Laura Potter and V&A Publishing for their enthusiasm and help. And, of course, to Paul, Oscar and Miranda for putting up with it all!

Author's Biography

Rachel Church is a Curator in the Sculpture, Metalwork, Ceramics and Glass Department at the Victoria and Albert Museum with a special responsibility for the rings collection. She has published and lectured on jewellery and worked on the redisplay of the William and Judith Bollinger Jewellery Gallery. She has contributed to a number of V&A publications, including writing on gold boxes in *The Gilbert Collection at the V&A* (2009).

Index

Page numbers in italics refer to captions

Abington, Dorothy 53 acrylic 121, 127, 145

Alathea, Countess of Arundel and Surrey 55, 59

Albert, Prince 82

Altieri, Marco Antonio 32

aluminium 123. 127

Amelia, Princess 75, 76, 77

amethyst 77, 101-2, 104-5, 117, 121

Appleby, Malcolm 141, 141

aquamarine 109, 111, 117

Arbus, André 109

Arnold, Matthew 69, 69

Arnold, Zoe 136, 142

Art Deco 98, 106-12

Art Nouveau 98

Arts and Crafts 98, 105

Asprey 115

Austen, Jane 69

Azagury-Partridge, Solange 141, 146, 147

Babetto, Giampaolo 135

Bach, Johann Christian 60, 62

Bacon, Sir Nicholas 50, 51

Bailey, Banks & Biddle Co. 111

Bakst, Leon 106

Bartholemeus Anglicus 10, 10

Batman, Stephen 25

Bauhaus 109

Beaton, Cecil 115, 117

Beaufort, Lady Joan 10, 12

Berguen, Robert de 59

Blackstone, Sir William 80

Bogo de Clare 10

Bolton, Martha 73 Boodles 144

Boteler family 53

Boucheron 115, *115*

Boyvin, Réné 30, 34

Broaden, John 160

brogacii, soiiii ro

bronze 8, 21, 145

Browne, Sir Thomas 33

Burges, William 85

Buxton, Dr Samuel 70

Calder, Alexander 113, 113

Canteron, Étienne 59

Capellanus, Andreas 10

Cartier 106, 106

Cartlidge, Barbara 118, 121

Castellani 82

Catherine of Braganza 56

Cave, Susie 146

Cellini, Benvenuto 30, 82

chalcedony 52, 53, 104, 108

Chanel, Coco 109

Chang, Peter 141, 145

Charles I, King 55, 56

Charles II, King 56

Charlotte, Queen 69, 75

Chaumet 115

Chicho, Galgano d'23

children's rings 30, 36

Christie, James 60

claddagh rings 62, 66, 150

Coates, Kevin 130, 131

Cope, Edward 48

Croker, Thomas Crofton 82

Dahm, Johanna 139, 141

D'Aragona, Camilla 32

Darby, Hannah 95

De Beers 113, 118, 121, 126

Decker, Ute 141, 143

Delaune, Étienne 30

Després, Jean 109, 109

Diaghilev, Sergei 106 diamond rings 10, 16, 17, 30, 32–3, 35–6, 38, 40–1, 43,

55, 59, 60, 63, 65–6, 69–70, 76–7, 84, 89, 92, 95,

97, 105, 106, 108, 109, 111–12, 113, 124–5, 133, 141,

142, 144

Donne, John 30

Doyle, Roger 141

Dunlop, Sibyl 98, 104

Durand, Guillaume 17

Edward, Prince of Wales 109

Elizabeth I, Queen 30, 51

emeralds 55, 65, 76-7, 82, 101, 112

enamelled rings 35, 37–8, 41, 43, 46–8, 51, 56, 58–9, 63,

66, 69, 70-2, 74-7, 79, 84-5, 89, 93, 95-7, 128, 140, 147. 150

engagement rings 17, 33, 41, 60, 72, 103, 106, 107, 113, 118, 121

episcopal rings 10, 23

eternity rings 121, 124

Evelyn, John 49

Faber, Felix 23

fede rings 17, 17, 62, 150

Fielding, Robert 68

Fiorentino, Rosso 34

Fishberg, Nathan 105

Flöckinger, Gerda 118, 122

Fok, Nora 136, 136

Fouquet, Georges 108, 109

France, Marie de 10

158 RINGS

Frederick Augustus, Duke of York 69 French, John 160 Fritsch, Karl 138

Froment-Meurice, François-Désiré 82, 84, 96, 97

Gage, Elizabeth 121, 126 Gainsborough, Thomas 62 Garle, Mr J. 72, 74

Odile, 1-11 5.72, 74

garnets 58, 63, 101-2, 128, 137, 142

Garrard, Dame Cecilia 70 garter rings 76, 77

Gellius, Aulus 33 George III, King 69, 70, 75, 77

George IV, King 75, 89 giardinetti rings 60, 65, 150

Gillray, James 78

gimmel rings 32, 41, 42, 150 Giuliano, Carlo 85, 101 Gledhill, Lucie 141, 142 Glover, Samuel 75

Godman and Rabey 9, 115, 115

gold rings 13–16, 18–20, 22–3, 26–28, 30, 32–3, 35–6, 38, 41, 43–4, 46, 48–9, 51–3, 55–9, 60, 63, 65, 69–77, 79–8, 84–5, 87–9, 92–7, 101–4, 108–9, 111, 115, 117, 120, 122, 124–6, 128, 130–1, 133–5, 137–40, 142, 144

Goldsmiths 82 Goldsmiths Journal 106 Gosschalk, Michael 115, 117 Gresham, Sir Thomas 41, 51, 52 Grey, Lady Catherine 32–3 Grima, Andrew 118, 121, 123 gypsy setting 89, 150

Halford, William 94 hallmarks 8, 82 Hamilton, Emma 75 Hardwicke, Lord 68-9 Harrison, Butterfield 70, 74

Hart Schaffner and Marx Fine Clothes 98

Hatton, Sir Christopher 30 Henry, Lord Neville 30 Henry VIII, King 30, 51, 53 Hensel, David 130, 132 Hesketh, Lady 82 Hill, Robert 48

Holworthy, Daniel 73

Hopea-Untracht, Saara 118, 120

Hopton, Sir Owen 32-3

Horace 80 Houblon, Anne 70

Howell, Mrs Charles Augustus 86

Huysmans, Jacob 45

Ingres, Jean-Auguste-Dominique 60

Instone, Bernard 98, 104

intaglio 25, *27*–8, *52*–3, *56*, 150 Ishikawa, Mari 136, *138*

Jahn, A.C.C. 98, 103 James I, King 33 James II, King 55, 55, 97 Jeweller and Metalworker 106 Jones, Arthur Morley 103

Klagmann, J. B. 84

Kodré Defner, Elisabeth 136, 137

Kutchinsky 121, 124

Lalique, René 98

Lavater, Johann Kaspar 81

Leane, Shaun 144 Lee, Sir Henry 30

Lee, Katherine and Christian 51, 51

Lee, Richard 51, 52 Lefèbre, François 59 Lefebvre 82, 90–1 Legaré, Gilles 59 Leigh, John 8, 60, 74 Lepec, Charles 84

Lepeletier de St Fargeau, Louis-Michel 77

Lethaby, W. R. 98, 100, 101 Loughridge, Tom 126 Louis XI, King 23 Louis XVI, King 77 Louis-Philippe, King 97

Macrobius 33

magical properties 10, 22, 23, 25, 30, 150

Maierhofer, Fritz 121, 123, *127* Marat, Jean-Paul 77

Marbodus, Bishop of Rennes 10 Marchak, Alexandre 106, 108

Martin, William 94 Mary, Princess 69

Mauboussin 106 Medici, Cosimo de' 40

Medusa 30, 32

Mason, George 70

memento mori 46, 48, 150

memorial and mourning rings 8, 46–7, 48–9, 56, 69–75,

75-6, 77, 79, 94, 95, 97, 150, 160

micro-mosaics 82, 87, 150 Miers, John 80, 81 Mignot, Daniel 30

Moncure, John 70

Mor, Anthonis van Dashorst 30

Morice, Thomas 55 Morris, Jane 88 Morris, May 101

Morris, William 88, 98, 101

Mueller, Louis 134

Murphy, Henry George 98, 105

Mytens, Daniel 55

Nelson, Admiral Horatio 75, 78, 79

Nelson, Dr William 75

Neoclassical-style rings 60, 62, 67, 74, 82, 87

Newman-Newman, James 75, 79

Nichol, Thomas 30, 32

Nicholets, Samuell 47

O'Connor, Harold 130, 130

opal 103, 122, 137

Ossian Hopea 118

Oxinden, Henry 59

Packard, Gillian 121, 124

Paganin, Barbara 136, 137

Palmer, Emily 97

Papendiek, Mrs Charlotte 69

Partridge, Fred 105

pearls 58, 102, 104, 135, 136

Pearson, Reginald 98, 103

Pepys, Samuel 41, 49

Perceval, Spencer 75, 75

Phillips, Robert 84
Piggott, Sir Richard 49

platinum rings 105, 106, 108, 109, 111-12, 124, 132, 144

Pliny 10

Pointon, Marcia 60

Pollaiuolo, Antonio 40

posy rings 17, 32, 41-6, 151

Pouget, J.B. 65

Prince, Edmund 80

Quin, Dr Henry 81

Ramshaw, Wendy 123, 128, 129

Ricketts, Charles 101

Robinson, Andrew 66

rock crystal 72-3, 76, 56, 59, 109, 133

Rococo-style rings 62, 74, 82

Rogers, Ginger 109, 111

Rothmann, Gerd 130, 134

Roy, Dolf van 107

rubies 32, 35, 60, 63, 65, 89, 101, 104, 111, 117, 126,

131, 141

Rundell, Bridge and Rundell 76

Ruskin, John 98

Ryan, Jacqueline 136, 140

Salter, John 75, 79

Sandys, Frederick 82, 86

sapphires 10, 13, 16, 27, 30, 32, 33, 35, 85, 101-4, 112

Saumarez Smith, Romilly 141, 142

Schaefer, Fabrice 136, 140

Schobinger, Bernhard 130, 135, 136

Scott, Charles and William 94

Senonnes, Madame de 60

serjeant's rings 55, 57, 80

Sforza, Constanzo 32

Shakespeare, William 48

Shaw, Dame Anna Maria 69

signet rings 25, 26, 29, 49, 51, 53, 94, 150, 151

silver rings 17, 21, 26, 29, 30, 63, 77, 80, 96, 104-5, 113,

121-2, 127, 130, 132-4, 136, 137, 138, 140, 147

Sitwell, Edith 115, 117

spectrolite 120, 130, 130

Syllas, Charlotte de 130, 132, 133

Tassie, James 81

Thackeray, William Makepeace 94

Thé, Jeanne 118, *125*

Theophrastus 10

Thiry, Leonard 34

Thomas de Rogeriis de Suessa 25, 28

Thomson, William 94, 94

toadstone 24, 25, 151

tourmaline 102, 122, 126

Toutin, Jean 59

turquoise 30, 32, 36, 38, 86, 92, 115, 120

Twiggy 118

Van Cleef & Arpels 106, 112

Verney, Sir Ralph 49

Victoria, Queen 82

Virgil 13

Waldegrave, George, 7th Earl of 94, 95, 97

Walpole, Horace 97

Walter, Barbara 130, 133

Walton, Izzak 45

Washington, George 70

wedding rings 8, 32-46, 60, 62-9, 82, 88, 106, 113,

141, 141

Wedgwood 81, 81

Wilson, Henry 98, 101

Wiraman, Gabriel 72, 74

Woeiriot, Pierre 30, 39

Worshipful Company of Goldsmiths 121

Wright & Teague 141, 143

Wyatt, Ethel Williamson 98, 102

Wytlesey, William 10, 13

Young, Charles 94

Zenobius, St 23

Frontispiece: Miss Piggy Ring (from the installation 'Wanna Swap Your Ring', 2010).

Photo Atelier Ted Noten

p.4: Publicity photograph for Everywoman by John French. England, 1965.

John French Archive, Victoria and Albert Museum, AAD/1979/9. © John French/Victoria and Albert Museum, London.

pp.7-8: Designs for mourning rings from an album produced for the firm of John Brogden (1864-84). V&A: F:2:448-1986

First published in the United Kingdom in 2011 by the Victoria and Albert Museum.

This revised and expanded edition first published in the United Kingdom in 2017 by Thames & Hudson in association with the Victoria and Albert Museum as part of the V&A Accessories series.

Rings © 2017 Victoria and Albert Museum/ Thames & Hudson

Text and V&A photographs © 2017 Victoria and Albert Museum

Design and layout © 2017 Thames & Hudson

Designed by Angela Won-Yin Mak

All Rights Reserved. No part of this publication may be reproduced or transmitted in any form or by any means, electronic or mechanical, including photocopy, recording or any other information storage and retrieval system, without prior permission in writing from the publisher.

British Library Cataloguing-in-Publication Data

A catalogue record for this book is available from the British Library

ISBN 978-0-500-51974-5

Printed and bound in China by Toppan Leefung Printing Limited

To find out about all our publications, please visit www.thamesandhudson.com There you can subscribe to our e-newsletter, browse or download our current catalogue, and buy any titles that are in print.

V&A Publishing

Supporting the world's leading museum of art and design, the Victoria and Albert Museum, London